IMPRESSIONIST GARDENS

JUDITH BUMPUS

BARNES
&NOBLE
BOOKS
NEW YORK

To Nicola and Francesca

This edition published by Barnes & Noble Inc.,
by arrangement with Phaidon Press Limited.

© 1990 Phaidon Press Limited
Text © 1990 Judith Bumpus
1995 Barnes & Noble Books

ISBN 1-56619-729-5

Printed in Singapore

M 10 9 8 7 6 5 4 3 2 1

(*endpapers*) Monet painting in his garden at Giverny. Photo: Collection Piguet

(*half-title page*) 1 EDOUARD MANET *The Bench* (detail) 1881
Oil on canvas 65 × 81 cm (25⅝ × 32in) Private Collection

(*title page*) 2 CLAUDE MONET *Gladioli* 1876
Oil on canvas 55 × 82 cm (21⅝ × 32¼in) Detroit Institute of Arts

(*opposite*) 3 PIERRE-AUGUSTE RENOIR *Monet Painting in his Garden in Argenteuil* 1873
Oil on canvas 46 × 60 cm (18 × 23½in) Wadsworth Atheneum, Hartford

(*pages 6–7*) 4 CLAUDE MONET *The Tuileries* 1876
Oil on canvas 54 × 73 cm (21¼ × 28¾in) Musée Marmottan, Paris

CONTENTS

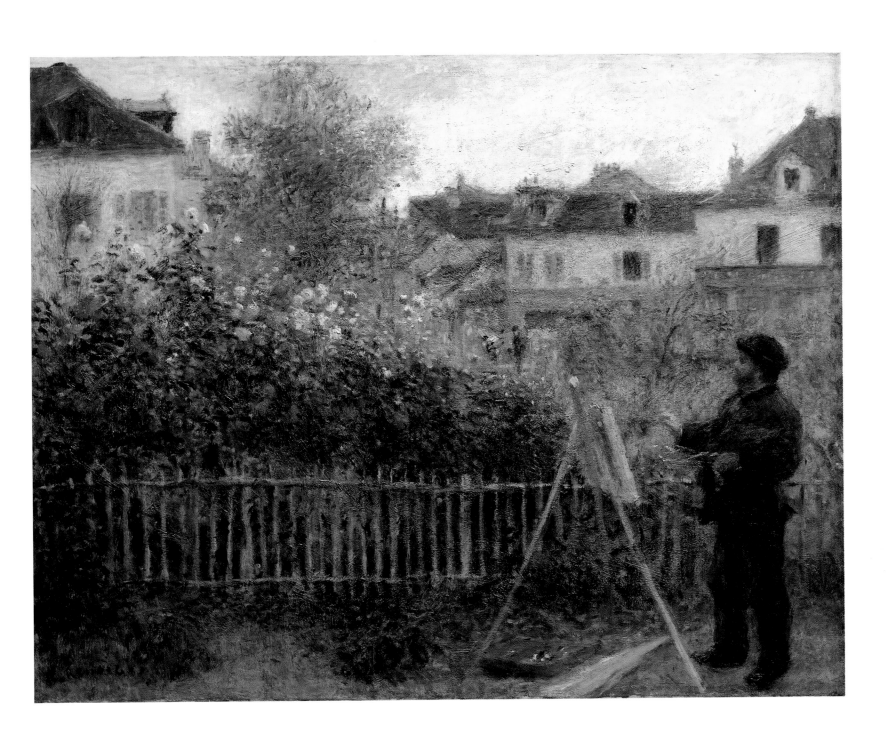

5

BERTHE MORISOT (1841–95) *Eugène Manet and his Daughter at Bougival* 1881
Oil on canvas 73 × 92 cm (28³/₄ × 36¹/₄ in)
Private Collection

(Berthe Morisot married Edouard Manet's brother, Eugène, in 1874)

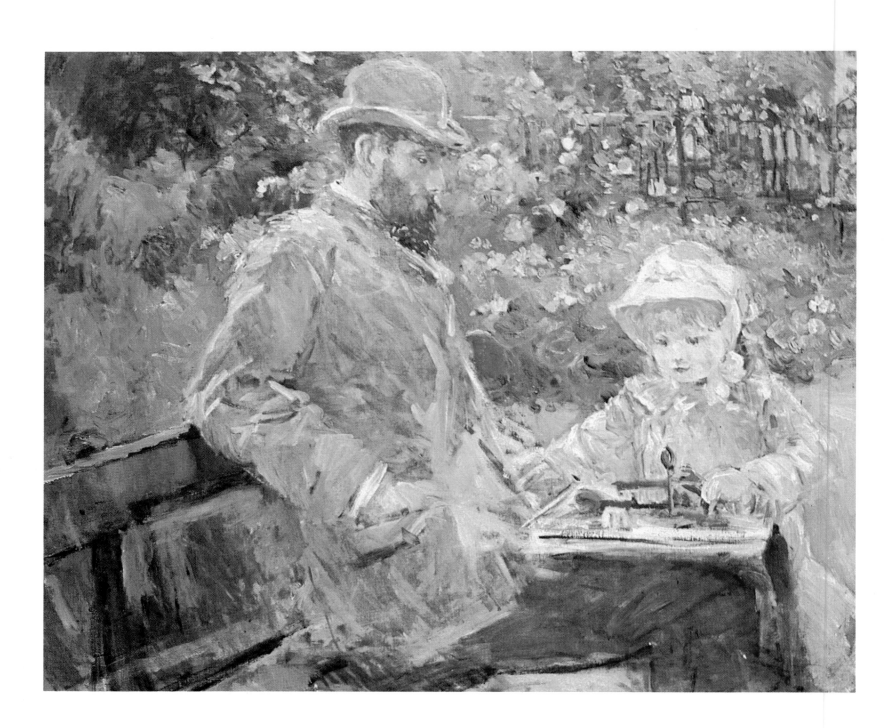

IMPRESSIONIST GARDENS

'The eternal joys, the eternal youth of the open air'
EMILE ZOLA *La Curée*, 1871

Nineteenth-century France was an age of garden culture which, surprisingly, and unlike England at that time, produced no specialist garden painters. It may seem perverse to open a book on Impressionist gardens with this statement, for the art of the latter part of the period has a special place in the affections of garden lovers. No century before or since has given birth to a group of artists who were able to evoke the atmosphere of the garden with such lyrical probity as did the Impressionists and fresh-air painters inspired by them.

Claude Monet, Auguste Renoir, Berthe Morisot, Gustave Caillebotte, Frédéric Bazille, Camille Pissarro, Alfred Sisley, Edouard Manet and Vincent van Gogh, all saw the garden as a place of beauty and revelation, and with them we step into light and air as if for the first time. Out of impulsive brushwork and sheer playfulness, they discovered a way of conveying their sense of delight, in paint that sparkles, collides and quivers with enjoyment. If these artists opened our eyes to what impressed them in nature, they were able to suggest the experience even more persuasively to our other senses. The Impressionists' gardens are alive with scents and breezes. Their rendering of grass, foliage and flowers not only transports us visually into their pictures, but imaginatively out into the enveloping air, which itself seems to have been tinged by the radiance of the garden. Caillebotte, Gustave Geffroy recalled, 'loved flowers that coloured and perfumed the air'. And the same critic observed that in Berthe Morisot's paintings 'pink, pale green, faintly gilded light sings with an inexpressible harmony' (Pl. 5).

With few exceptions, the garden life depicted by the Impressionists was that of spring, summer and early autumn, warm-weather seasons in which nature and humankind are lured into closest unity of spirit and activity. It was a perfect world of sunshine and colour, where ladylike pursuits were acknowledged, but seldom the labours of the working gardener (Pls. 11 and 19). Effects of frost or snow which preoccupied the Impressionists in their studies of seasonal change in the landscape were rare too. Their susceptibility to the glow of winter light on bare branches or to the prismatic reflections from a garden under snow gave way to a surge of fevered excitement as the sun encouraged the first signs of colour from flowering trees, and gradually illuminated the garden into full summer brilliance.

Yet the essential subject of the Impressionists' pictures was not garden portraiture. Neither garden design, nor the literal depiction of plants in growth were among their primary concerns. If

Impressionist gardens seduce us with their colour, we look in vain among their displays for an occasion to admire the prospect of a well-stocked border and to linger over details of their bedding (Pl. 44 and title page). Where English late Victorian watercolourists, such as George Samuel Elgood (1851–1943) or Ernest Arthur Rowe (1862–1922), featured the splendour of gardens at the height of an eternal summer, the Impressionists' election of this patch or that corner often seems arbitrary, banal almost. But too much can be made of the ordinariness of their subjects. The Impressionists enhanced even the most unpromising ground with a note of picturesque prettiness.

There is a feeling of wistfulness for the moment that has passed. But the aura of perfection surrounding English work is entirely absent from the Impressionist concept of the garden. Content with the beauty of nature as they found it, the Impressionists made no obvious effort to tidy up the garden, or to present it for show in the English way. As we know, they worked over their *plein-air* paintings in the studio in order to convey the unifying effect of light. It was a way of making their rough transcriptions pictorially coherent, not an attempt to improve their subject. By whatever means, they aspired always to retain the spontaneity and freshness of their first impression.

Although their aims diverged, an interesting parallel exists between the ideals of another group of English nineteenth-century artists and the Impressionist explorations. The Pre-Raphaelite painters' technique of studying nature on the spot and of translating it in clear, glowing colours anticipated the French initiative by two decades. While their practice had no influence on the Impressionists, it must have been assimilated into the visual thinking of the English watercolourists. Yet the air of artificiality that lingered around English painting was curiously at odds with the naturalness of its subject and it was the idea of naturalness that caught the Impressionist imagination. Not for them the visual order of their own native garden style, the rational layout of what Lucien Corpechot described in 1911 as 'gardens of intelligence'. Although Manet expressed a wish to paint André le Nôtre's garden at Versailles, these vistas never attracted the true Impressionists. Instead, they preferred the emotive appeal of English eighteenth-century gardening, which intrigued the eye with its mysteriously disappearing paths, and which blurred the clear-cut lines of fence or flower-bed with a sprawl of roses and nasturtiums. And so when Monet painted the Tuileries Gardens, his view from an apartment in the rue de Rivoli framed them at an angle, and he deliberately obscured le Nôtre's symmetrical structure with the foliage of chestnuts in flower (Pl. 4). The Impressionists' understanding of how much of a garden makes a picture was quite distinct from the English choice of the superabundant herbaceous border. Their pretensions being altogether more modest, the

6

CAMILLE PISSARRO (1830–1903) *Corner of the Garden*
at the Hermitage (detail of Plate 22)

gardens they painted came closer to what Zola described in his novel *La Curée*—a vivid contemporary portrait of the new Paris—as a 'smiling bit of nature'.

What chiefly distinguished the Impressionists from English artists was the inventive manner in which they animated that 'bit' of nature. With strokes, curls and dabs of paint applied with unconventional freedom, they treated us, characteristically, to a lively, if summary, impression of the joys of the open air—a pleasant, generalized sensation of sunlight and colour at a particular time of day. Extemporary brushstrokes and, pre-eminently, colour became their key to a more lively and atmospheric naturalism. When the Impressionists moved their studios outside and set up their easels in sunny gardens, it was to borrow the brilliant palette they found there (Pl. 3). Dark tones were dispersed by their confident optimism, and replaced by the pure and contrasting colours they discerned in natural phenomena, even in shadows. Suffused with the bright light of outdoors the individual features of flowers disappeared in a panoply of colour, within which the complexion of a rose, geranium or gladiolus, still just recognizable as such, stood out as vivid enticements (Pl. 27). For these artists, a spontaneous rendering, however sketchy, if made outdoors in immediate response to nature, was truer to the experience than an image assembled over a period of time. In liberating themselves from the need to accumulate precise detail on the canvas, they could concentrate all their energies on catching the intangible and constantly changing elements of light and air—the essence of outdoors.

The spirit of Jean-Jacques Rousseau (1712–78), that eighteenth-century advocate of the natural life, survived unmistakably in the Impressionists' belief in nature. It was Rousseau who awakened the sensibilities of his countrymen to the pleasures of walking, to the beauties of wild flowers and to the benefits of studying nature. 'The countryside is my study,' he declared. A century later Monet and his friends echoed these sentiments when they followed the Barbizon School into the landscape, commending nature, but without Rousseau's moral overtones, as their studio. The move met with a reprimand from Monet's cousin and tutor, the fashionable society painter, Auguste Toulmouche (1829–90), who counted it 'a serious mistake to have deserted the studio so soon'. Monet replied promptly: 'I haven't deserted it at all. I have found a thousand charming things here that I couldn't resist.' But where Rousseau and the Barbizon artists favoured nature in the raw, Monet and his friends were drawn back to the charms of nature as garden. Their corners of nature, enclosed in public parks or private gardens, could have found their place in everyman's notion of

7

CLAUDE MONET (1840–1926) *Terrace at Sainte-Adresse* (detail of Plate 27)

8

PIERRE-AUGUSTE RENOIR (1841–1919)
Garden in the rue Cortot, Montmartre
(detail of Plate 26)

earthly paradise. Even the flower-filled meadows they painted along the Seine lay only just beyond the line that divided the urban garden from the landscape proper. Poppy fields formed an extension, as it were, of the city's gardens and were populated by strolling day-trippers from the metropolis. For nature in Impressionist garden scenes was depicted as a social, not a solitary pleasure. And it was celebrated with even greater exhilaration for being drawn from their own experience of life and leisure in the open.

The persuasiveness with which the Impressionists engage us in their activities derives from the immediacy of that experience. They worked 'before Nature' in order to grasp its true character and their genius lay in making what they perceived both actual and more natural. They managed to convey a sense of life as it was lived. So that when we catch sight of mothers and children seated on the grass or under trees, of couples strolling among flowerbeds or relaxing on lawns, or of Monet stooping over his plants, we are beguiled by the artlessness of the occasion. Their very informality contributes to a semblance of truthfulness.

Interestingly, Impressionist painting accompanied the arrival of the snapshot, which was equally unselective and equally, if arguably, truthful. But the Impressionists trusted the evidence of their own eyes and did not rely on that of the camera in their search for realism. In any case, their aims and methods were the exact reverse of photographic reproduction, which paralleled more closely the verisimilitude achieved by academic painters. The Impressionists were intent on avoiding what they thought of as dead-handed imitation. Observation taught them that the optical truth of appearances was far more elusive than the frozen frame suggested. In their paintings the contours and bulk of solid forms dissolved into a shifting world that was continually in movement: light flickered, water rippled, leaves fluttered and petals vibrated.

On inspection, then, the Impressionist garden is an insubstantial illusion which seems to suggest that the Impressionists were less interested in the physique of plants than the English garden painters. On the contrary, several of the artists illustrated in this book, Monet, Renoir, Bazille and van Gogh in particular, made ravishingly painted flower-pieces. Passionate in their response to the beauty of nature as a whole, they were equally entranced by its details. When bad weather prevented their painting in the open air, they would concentrate their attentions on the qualities inherent in different species of flower, distinguishing posture and profile and subtleties of hue. That

9

CLAUDE MONET (1840–1926) *The Artist's Garden at Vétheuil* (detail) 1881 (dated 1880)
Oil on canvas 150 × 120 cm (59 × 47¼ in) National Gallery of Art, Washington DC

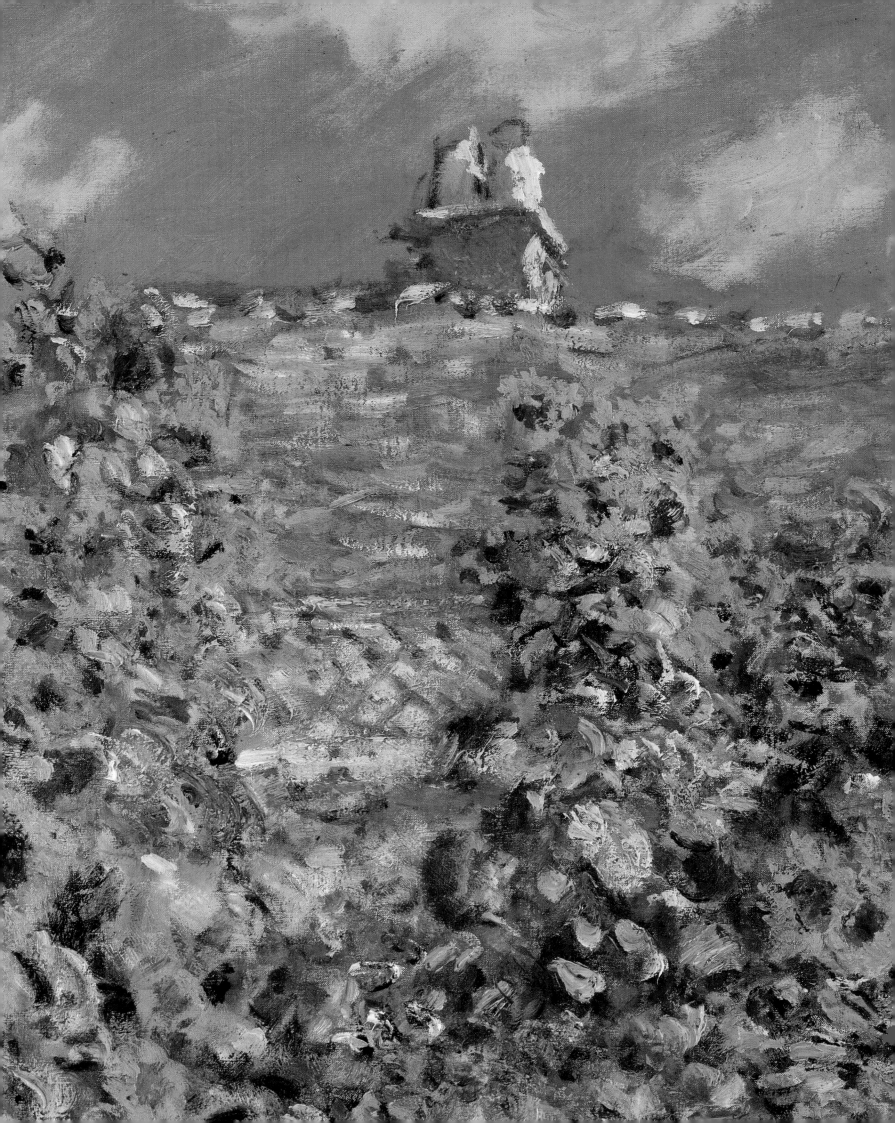

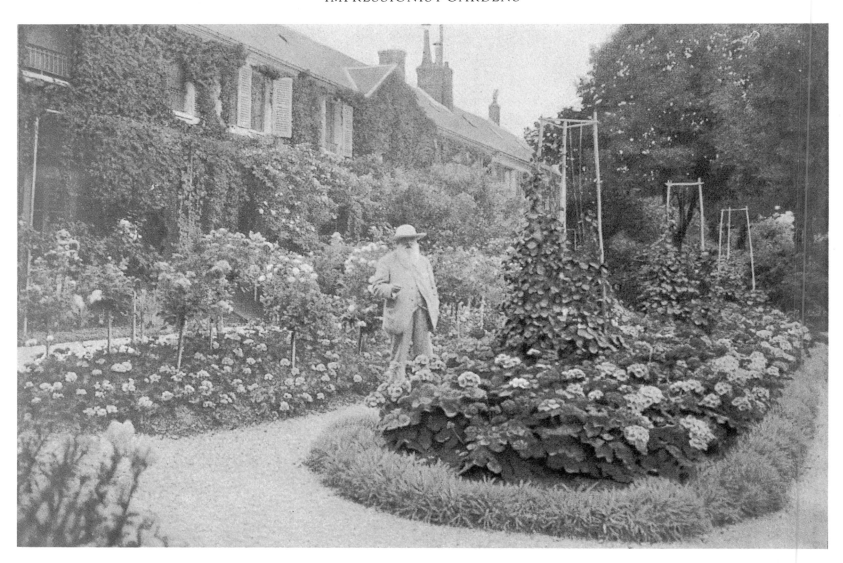

Monet was captivated by flowers quite early in his career is evident from an excited letter he wrote to Bazille in the summer of 1864:
'I must tell you that I'm sending my flower picture to the Rouen exhibition: there are some really beautiful flowers about at this time; sadly I've got so much to do on my outdoor studies that I dare not start on any, though I'd love to paint those gorgeous daisies. Why don't you do some yourself, since they are, I think an excellent thing to paint.'

Monet's enthusiasm was infectious, inspiring both Bazille and Renoir to produce beautiful floral still lifes around this time (Pl. 33). Throughout their careers Renoir, Monet and Caillebotte retained an affection for painting bunches of flowers, sometimes combined in elaborately composed still lifes and at other times, and increasingly as they got older, in simple, unpretentious arrangements of roses, daisies, gladioli or chrysanthemums. The decorative sight of flowers never failed to touch them and to induce a fresh outburst of wonder that still leaves us breathless (Pl. 21).

The closely focused study of plants made from time to time by the Impressionists explains their ability to abstract the characterizing shape of each flower and so to garnish their gardens with convincing, if occasionally ambiguous, equivalents. From early in their careers they painted in

10

Monet surrounded by borders of pinks, pelargoniums, cannas and
sages in his garden in Giverny at the height of its summer
splendour. Photo: Collection Agence Sygma

response to familiar surroundings: Monet's parents owned a summer residence at Sainte-Adresse in Normandy; Bazille's family spent the summer months at a house in Méric, near Montpellier; Caillebotte's had a property in Yerres in the Ile de France, where the extensive private park afforded motifs for many pictures. Like Pissarro and Sisley, Caillebotte took as much interest in the utilitarian aspects of the garden as in its flowers. Among paintings of picturesque winding paths at Yerres, its wooded walks and ornamental flowerbeds of red geraniums, he recorded neat rows of cabbages in the kitchen garden. But it is in the gardens of the Impressionists' own creation that we become most closely involved with their interests both as practical gardeners and as artist gardeners. Caillebotte, Pissarro and Monet all attended devotedly to their gardens: Caillebotte in Petit-Gennevilliers, Pissarro in Eragny and Monet in Argenteuil, Vétheuil and, most famously, in Giverny (Pls. 10 and 25). Where Pissarro clung to the look of the country garden, mixing flowers with vegetables and growing fruit trees, Monet and Caillebotte developed more specialized horticultural interests, planting unusual varieties of flower in exciting juxtapositions of colour. Their gardens provided a rich source of still-life arrangements and, particularly in the autumn when the dahlias and chrysanthemums were in full bloom, motifs for sumptuous colour compositions. Besides the familiar rose, marguerite and geranium, exotic flowers featured in their pictures, among them peonies, chrysanthemums and irises, inspired by the craze for woodblock prints and other things Japanese. Caillebotte, that 'wise amateur of the garden', as Gustave Geffroy called him, cultivated rare species of rose and filled his large greenhouse with tender plants and an impressive selection of orchids. Towards the end of his life he made a series of beautifully contemplated studies of these orchids to decorate his dining-room, a project influenced no doubt by the botanically inspired doors Monet painted for his dealer, Paul Durand-Ruel. The friendly correspondence sustained between Monet and Caillebotte reflected the artists' obsession with plants and with their gardens. 'I have received the dahlias safely,' Monet wrote to Caillebotte from Giverny on 12 May 1890. And later:

'Don't forget to come on Monday as arranged, all my irises will be in flower, later they will have faded.

Here is the name of the Japanese plant which I got from Belgium: Crythrochaete. Try to speak to M. Godefroy about it and to give me some information about its cultivation'.

On another occasion, a letter to Caillebotte related:

'I have seen the exhibition of flowers in Paris, wonderful things. I met your friend Godefroy there. Can you tell me where I can buy annuals. I have seen superb things at the exhibition, but it was too

11

GUSTAVE CAILLEBOTTE (1848–94) *Roses, Garden at Petit-Gennevilliers* (detail of Plate 34)

 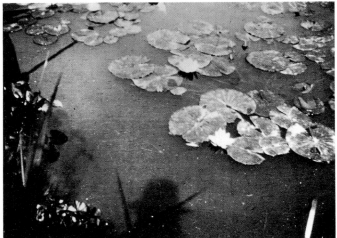

late to sow them, among others chrysanthemums . . . and Layias with yellow flowers, perhaps you would have some yourself, anyhow try to make some enquiries'.

Both men possessed means enough to employ gardeners, but the evidence of letters and photographs shows that they took a working interest in their gardens. So it is surprising, given their intense curiosity about plants, that they were so rarely deflected from their purpose as painters of impressions. As we have seen, the Impressionists had no hesitation in skating over the details of garden growth in order to communicate an instant effect which would embrace, and remain true to, their first vision.

Fidelity to what they saw determined the evident narrowness of that vision. Typically, Impressionist compositions were small-scale and included just as much of a garden as their eyes could absorb at a glance. The charm of Impressionist gardens lay in their intimacy and seclusion. 'I am in search of nooks and corners,' Pissarro wrote to his painter son, Lucien, in 1899. Only rarely do they attempt to widen that range. Monet, Pissarro and Sisley would occasionally adopt a raised viewpoint looking down on a Paris park or out over a suburban market garden. Their paintings offer us a sense of open space laid out with trees and lawns, or with rows of vegetables. But, in general the structure of gardens served the Impressionists only as a reference; it offered an artistic strategy, not a theme that was characteristically of Impressionist interest. A path stretching back to a house, or round a flowerbed invites the eye into a picture whose composition otherwise only hints at the garden's geography and, without the help of titles, it would be hard to identify a particular source of inspiration.

Monet has left an unforgettable series of paintings made in Giverny, just north of Paris. From 1883 he devoted himself entirely to designing his now famous ornamental gardens there. Month after month he cultivated a kaleidoscope of colour in what Proust described as 'less the old florist garden than a colourist garden'. And in canvas after canvas Monet pursued the aims of the Impressionists, registering the movement of colours in the shifting light of the garden. In doing so he gave us the most full-blown account of a garden left by any of the Impressionists. He took pleasure in showing his garden to visitors and yet the extensive series of paintings he made could hardly be counted a visual equivalent of the garden tours as related by contemporary writers. The magic of his Giverny paintings lies in the sum of their fluctuating effects. Enchanted by nature's decorative possibilities

12

Capturing the fleeting moment. Monet's figure reflected in his water-lily pond, an inexhaustible source of subject-matter for his studies of light on water. Photo: Collection Piguet

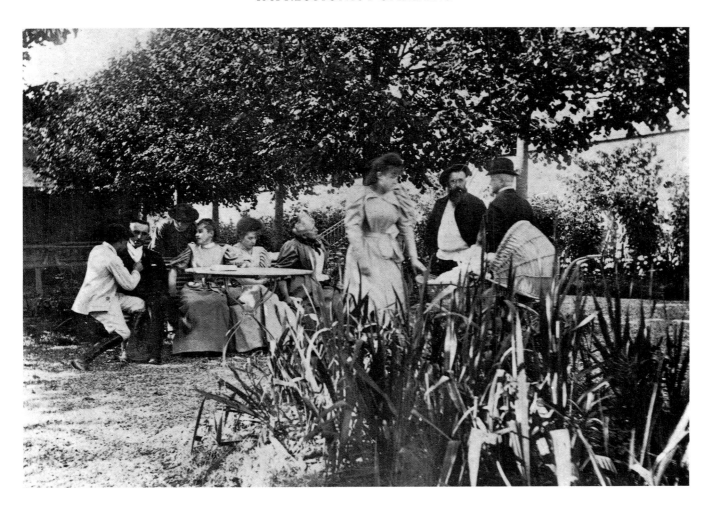

for the artist, he would paint the same parts of the garden over and over again until, immersed in his own vision, his canvases become dazzling expressions of pure sensation (Pl. 38). In 1926, just three months before he died aged eighty-six, he assessed his own achievement quite modestly in a letter to Evan Charteris:

'In the end, the only merit that I have is to have painted directly from nature with the aim of conveying my impressions in front of the most fugitive effects.'

The novelty of the Impressionist approach summed up by Monet in old age was not at first understood or appreciated by contemporary audiences, whose desire was for finely finished and varnished canvases. A closely wrought surface constructed of imperceptible touches of the brush was considered a measure both of the artist's competence and of his seriousness. Criticism of the Impressionists for failing to observe these standards and for taking, instead, the way of quick production and 'least effort' ignored their long apprenticeship before nature studying atmospheric effects. Rebellious though the Impressionists were, according to the expectations of the day, their contribution can be seen as a continuation, not a break with past tendencies. With hindsight we can view their work as the logical culmination of a growing interest in nature during the course of the nineteenth century and, historically, of a much lengthier attempt by artists to convey the atmosphere of the open air freshly and faithfully. In addition, the Impressionists' curiosity about nature was inextricably bound up with the expanding horizons of a bourgeois lifestyle and, as painters of modern life, they reflected the experience of nature enjoyed by the urban middle classes.

13

1893. Under the lime trees: Monet stands conversing with one of his stepdaughters and his friend Paul Durand-Ruel. Seated near them is Alice Hoschedé, Monet's second wife. Photo: Collection Piguet

To this extent their work can be seen to carry on a tradition that depicted French gardens as an expression of social life and manners.

Although two centuries apart in time and cultural milieu, the Impressionists were heirs to the most matter-of-fact purveyors of gardens, the topographical artists of the seventeenth century. In practice, artists such as Israel Silvestre, Gabrielle Perelle, Pierre Patel and Adam Francis van der Meulen offered more than documentary portraits of property. From the figures parading through the gardens of Louis XIV's château at Versailles we get a sense of court ritual observed as correctly outdoors in hedged corridors and geometric parterres as it was in the grandiose galleries of the royal interior.

In eighteenth-century painting, parade ground became playground for a society clearly bent on more relaxed and romantic pursuits. In the *fêtes galantes* of Watteau, Boucher and Fragonard, aristocratic leisure in gardens was made a theme in itself, encapsulating the idyllic pastimes of a carefree Parisian society that had rediscovered innocent pleasure in unspoilt nature.

Yet it is worth bearing in mind that these paintings kept a delicate balance between the artist's direct response to nature and his capacity to improvise. Watteau, for example, made sensitive sketches on the spot in the tradition of Claude. From his many drawings of the informal Luxembourg gardens, he would incorporate carefully observed details into his own airy fantasies. His finished paintings, while bearing no relation to actual situations, mirrored the festive atmosphere of country house entertainment.

By mid-eighteenth century the cult of nature required something more authentic, but its sophisticated notion of rusticity was satisfied with an approximation, as far divorced from the realities of the countryside as Watteau's pretty paintings. Boucher made meticulous drawings in the park of Arceuil on the Marne and, from real ingredients, created a romantic concoction that responded to Rousseau's ideal of the garden as a cultivated wilderness for human solitude and reflection.

The urge to paint scenes of genuine naturalism drove artists in the first half of the nineteenth century back to the wild and closer to the soil. In Fontainebleau Forest and its surroundings the

14

VINCENT VAN GOGH (1853–90) *The Garden of the Poets* (detail of Plate 39)

so-called Barbizon School of landscape artists found what they were in search of: unembellished nature and a traditional rural community. But if their subjects were more down-to-earth and, therefore, more realistic, their interpretation clung to the pastoral. Some of the younger generation who followed them went one step further in their attempt to retain what they felt to be the true experience of the open air, by not only working on the spot, but by presenting their spontaneous impressions as finished canvases. Above all they wanted to be modern and to present a fresh and contemporary approach to life. To do so they were drawn back to civilization, discovering the enjoyable effects of nature close to home, in and around the capital, in urban and suburban life and at nearby coastal resorts.

The nineteenth century was, as stated at the beginning, an age of garden culture. The city dweller's awareness of nature was greatly stimulated during the course of the Second Empire (1852–70) by the opening up and landscaping of Paris, and by easier access to the countryside and its gardens afforded by the developing railway system. The alterations imposed on the face of Paris during the Impressionists' lifetime were nothing if not radical. Under Napoleon III slums were cleared and, in the process, great areas of the city's network of narrow streets were swept away to make room for Baron Haussmann's grandly integrated plan of spacious squares linked by broad tree-lined avenues. Of special attraction to the Impressionists was Haussmann's vision for the greening of the city, with squares and parks laid out on the English model. In the fashionable city centre was the Parc Monceau, 'that indispensable flowerbed of the new Paris' as Zola called it. It was a picturesque subject for artists, and Monet and Caillebotte made several paintings there (Pls. 30 and 42). On the outskirts of the city, the Bois de Boulogne and the Bois de Vincennes were transformed by the landscape gardener Adolphe Alphand (1817–91) into great public parks inspired by London's Hyde Park. At the heart of Paris the Tuileries Gardens already contributed to the new sense of space and light which was a feature of Haussmann's redevelopment. The seventeenth-century palace of the Tuileries itself was gutted by Communard arsonists in 1871, leaving only the left wing, the Pavillon de Flore, intact. Monet ignored the ruin, concentrating instead on the open view. Here and there we catch glimpses between dense foliage of figures strolling among the statuary. The scene was an apt reflection of the garden philosophy of the eighteenth-century designer Jean-Marie Morel who, in his *Théorie des jardins* of 1776, maintained that open spaces in cities were there not for people to enjoy nature, but to exercise and be seen. For this very reason, it was reported in 1867, displaced slum dwellers objected to being moved to suburban apartments. As it was pointed out, 'they attach

15

CLAUDE MONET (1840–1926) *The Japanese Bridge*
(detail of Plate 38)

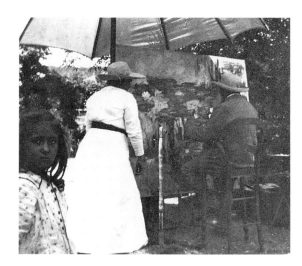

the highest price to the continuous spectacle presented by the boulevards, the public gardens and the main streets of a large town; they find in this a source of enjoyment that costs nothing.'

There is no doubt that the cultivation of *rus in urbe* provided both sensual as well as social pleasure for inhabitants of the new and somewhat alienating environment of the restructured capital. In one direction the nature trail took Parisians on foot or by boat along the Seine, or by train into the surrounding countryside, and in the other, into the bustling life of the city. Parks and gardens provided a bridge between the two worlds, typified by the open-air café among trees. During the nineteenth century, café life had become to the ordinary citizen what the elegant world of the 'salons' had been to the elite of eighteenth-century society. Cafés represented the 'democratisation' of the 'salon', as the historian Theodore Zeldin expressed it. We have only to compare the park and garden scenes painted by the Impressionists—Renoir's expression of youthful *joie de vivre* in the *Dance at the Moulin de la Galette* (1876), for example, or Monet's *Women in the Garden* (Pl. 32)—with the open-air 'salon' life depicted by Watteau or Fragonard to see how the interpretation of social behaviour had been modified by bourgeois expectations. Since Monet and Renoir admired these eighteenth-century artists, it is not surprising that the heightened mood of their paintings remained none the less close.

The democratization of aristocratic manners manifested itself in other ways and these too were absorbed as Impressionist themes. As Zeldin pointed out, the middle classes harboured ambitions: 'Though they praised work, their ideal was also to live off a private income, to have a house in the country, and divide their time between it and the town in exactly the same way as the aristocracy.' This aspiration was met by a boom in speculative building, in the construction of town houses with gardens and of country residences. Smaller properties were available for renting at weekends, or for summer holidays.

The private gardening that accompanied this building must undoubtedly have received a stimulus from the activity in Paris. Its rise was supported by the publication of magazines and practical manuals, some of which catered to an amateur middle-class readership, others in more lavish editions were aimed at the wealthy with large properties to landscape. Others still were designed to encourage the commercial market by offering advice to growers. One such, *Le Jardin: Journal d'horticulture générale*, described in its first issue in 1887 a manifestation of the gardening craze:

16

Monet, shaded by a large white umbrella, working in his garden in Giverny, with his stepdaughter Blanche beside him and a grandchild, Nitou Salerou, in the foreground. Photo: Collection Piguet

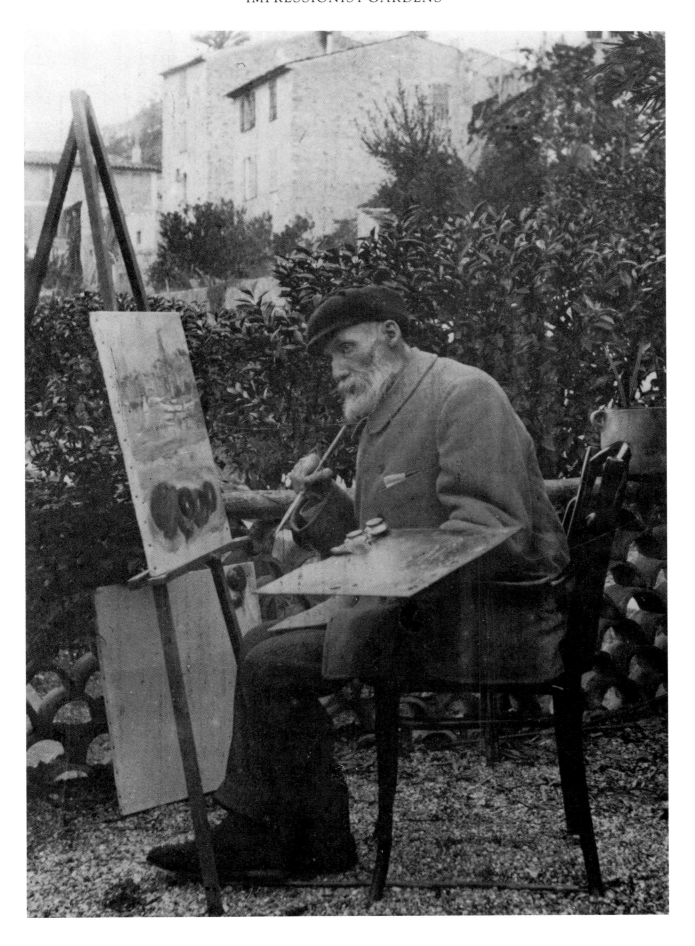

17

Renoir in old age, his hands crippled with arthritis,
painting at the Villa de la Poste, Cagnes.
Photo: Collection Durand-Ruel

18

FREDERIC BAZILLE (1841–70)
Flower Pots
(detail of Plate 33)

'In no other era have flowers and plants been so widely appreciated: they preside at all our ceremonies, take part in all our festivities, their use has been increased a hundredfold in twenty years, and their mass cultivation has become a source of revenue for many regions formerly in dire straits.'

The building of the railway greatly assisted this enterprise: as new lines were opened, fresh garden produce was brought from areas surrounding Paris to its central markets. By November 1871, fresh flowers could be transported by rail from the Côte d'Azur to the capital in twenty-four hours.

During a brief stay in Paris, Van Gogh was the grateful recipient of many gifts of plants and cut flowers and from these, as we can see from a wealth of beautiful still lifes, he experimented with the brilliant technique of the Impressionists. But, in common with other city dwellers, he yearned for nature itself. Apart from Bazille, a native of Montpellier, the Impressionists found the atmospheric effects they wanted in the moist climate of northern France, and they remained there throughout their careers. Van Gogh went south in search of heat and of even greater intensity of light and colour. There, his Yellow House in Arles symbolized a new and liberated life of simplicity, happiness and regeneration in the countryside of Provence.

Wealthy Parisians, too, pursued a pastoral ideal. Catering for their needs, luxury villas with flowery gardens sprang up on the Normandy coast and inland, alongside more rustic-looking houses with thatched roofs (Pl. 44). Ordinary middle-class families could rent a summer property such as the one Manet took in Versailles to regain his health, or the one Berthe Morisot enjoyed in Bougival, a popular bathing place along the Seine, not far from Paris. While cartoonists poked fun at city folk aping their country cousins, Impressionist painting expressed a pervasive belief in the restorative powers of nature. As the writer Georges Lecomte observed in 1892: 'We find the peace of flowered fields, vast expanses of tranquillity. These natural harmonies sound a gentle note on office walls. Like a bay window opening onto rural areas.' Manet was known to grumble that 'the country has charms only for those who are not obliged to stay there'. But other visitors to the countryside soon discovered that it failed to live up to its idyllic reputation, and that the view from the bay window onto unspoilt nature was often impeded by the very signs of commerce and industry that city people attempted to evade. In a coastal resort like Trouville, Caillebotte could still encounter rural calm and privacy, but in Argenteuil the story was different. The pace of speculative building and

19

EDOUARD MANET (1832–83) *The Monet Family in their Garden in Argenteuil* (detail of Plate 29)

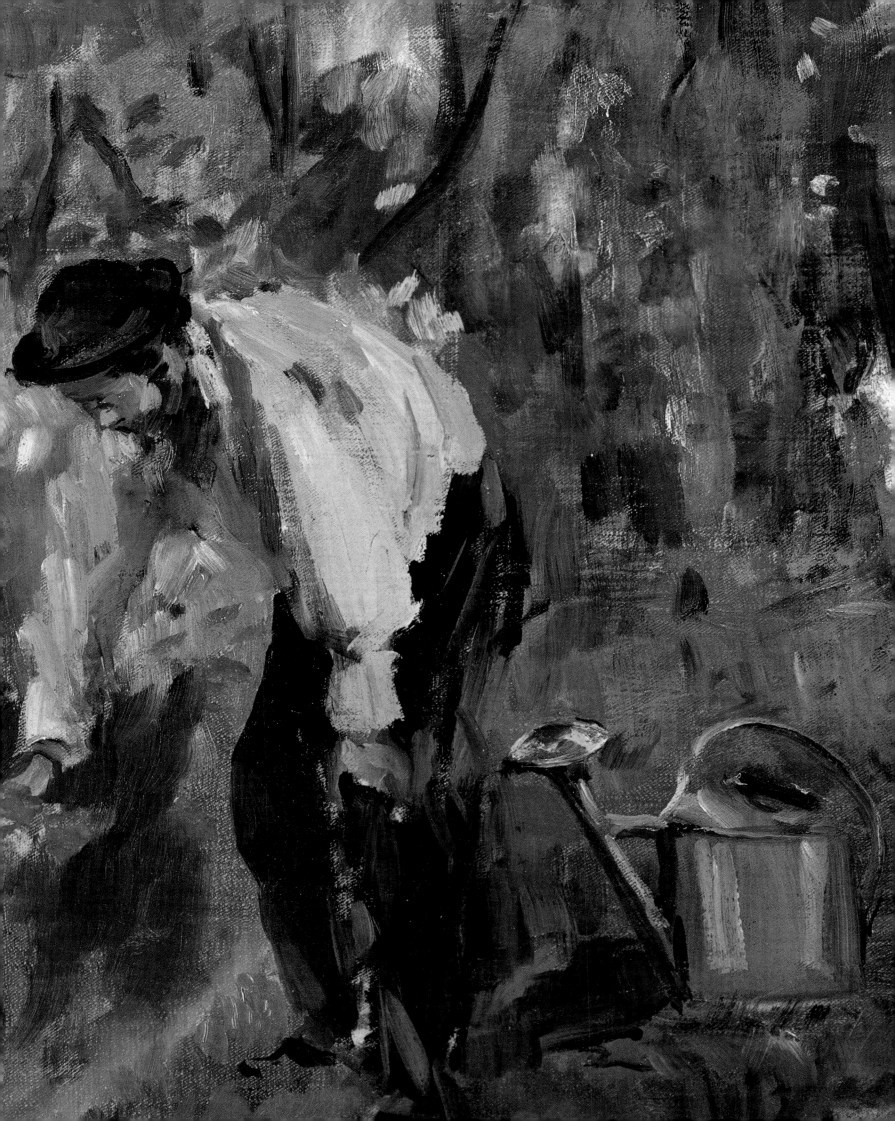

industrialization was such that Monet was given to embellishing nature in order to disguise the intrusion of man-made elements. Far from living in rural seclusion, Renoir's portrait of Monet painting his garden in Argenteuil showed him hemmed in and overlooked by neighbours (Pl. 3).

Although the Impressionists embraced modernity, they found themselves increasingly in retreat from its realities. They returned to the capital at intervals, but they preferred to live in the suburbs or in towns and villages along the Seine, where the contrast with city life fostered their rosy view of nature. Pissarro in Pontoise and then in Eragny remained closest to rural France and the practical activities of cabbage planting or fruit growing. 'Beauty is everywhere, if you know where to look for it,' he maintained. Caillebotte and Monet surrounded themselves with more ornamental beauty in their gardens in Petit-Gennevilliers and in Giverny. Alone among the Impressionists Renoir chose to stay in Paris, where he found a picturesque refuge in an overgrown garden in Montmartre.

The Impressionists gave us, uniquely, the fresh-air experience of the new world of leisure and outdoor entertainment. They observed contemporary throngs on beaches and boulevards, in parks and cafés. But they also withdrew to continue socializing in the privacy of their gardens. There they lived largely for themselves and the day-to-day activities of their families, and for the timeless enjoyment of cultivating their own 'smiling bit of nature'. Such, perhaps, is the true nature of gardens. They enclose us and, for a while, the world can be held at bay. Jean Renoir in the 'life' he wrote of his father likened the blissful bohemian haunt in the rue Girardon in Montmartre to Watteau's *Embarkation for the Island of Cythera*. For the Impressionist painters of modern democratic life, as much as for earlier artists who interpreted nature through the eyes of society's elite, the garden was, indeed, both a reality and an ideal. The Impressionists created an earthly paradise in terms that were closer to the everyday experience of their contemporaries. And they tried to re-create the actual sensation of being in the open air. But if their subjects were commonplace, their concept of the garden was equally and elusively romantic. In describing the rue Girardon, Jean Renoir caught the meaning of the garden for the nineteenth-century bourgeois: 'The inhabitants, enclosed within the high hedge and enjoying a certain privacy behind the fences of their own small gardens, dwelt in a world apart, concealing endless fantasy under a provincial exterior.'

It was this world that the Impressionists celebrated, with their paintings of gardens drenched in colour and sun.

20

PIERRE-AUGUSTE RENOIR (1841–1919) *On the Terrace* (detail of Plate 41)

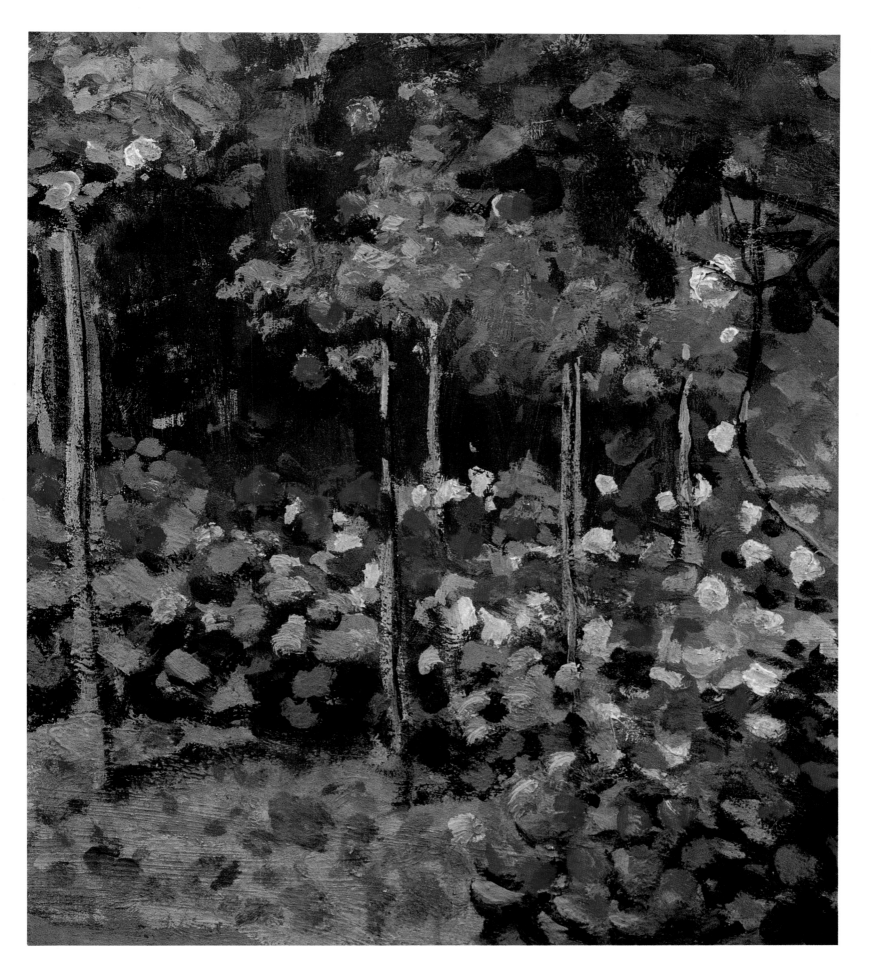

21

CLAUDE MONET (1840–1926) *Flowering Garden* (detail) *c.*1866
Oil on canvas 65 × 54 cm (25¹/₂ × 21¹/₄ in) Musée d'Orsay, Paris

CAMILLE PISSARRO
(1830–1903)

Corner of the Garden at the Hermitage
(detail) 1877

Oil on canvas 55 × 46 cm (21⅝ × 18⅛ in)
Musée d'Orsay, Paris

This tranquil summer scene could be taken as typical of the open-air 'nooks and corners' Pissarro went in search of. He felt at home in nature everywhere and, as we know from his rapturous response to the gardens and countryside of Eragny, he made no distinction between one aspect of natural beauty and another. But a private garden such as the one illustrated here was less characteristic of his rural themes, and the motif may have been prompted by other Impressionist paintings of gardens, such as Monet's of the Parc Monceau in Paris, which was shown at the third Impressionist exhibition in spring the same year (Pl. 30).

Pissarro's scene is in Pontoise. Two young girls are playing quietly together in a private garden. Pissarro discovered the market town, which lay some thirty kilometres northwest of Paris on the River Oise, in January 1866, just three years after the railway line from Paris was opened. Six years later he returned there after a visit to London had offered him refuge from the Franco-Prussian war. Staying in the hamlet of l'Hermitage, he persuaded the proprietor of the Château des Mathurins to let him work in its grounds. The first painting he made there showed a front view of the house, with its handsome, well-kept pleasure garden (Pl. 43). The mood is bright and open. In the summer of 1877 he painted two others, of which this is the smaller: a secluded, intimate spot, rendered more secretive by its darker palette. Pissarro has used a varied repertory of marks to establish the weather conditions, which send gentle vibrations through the garden.

Later he found it difficult to generate the same excitement about the season. As he wrote in a letter to his son Lucien in 1893, 'I can't endure the summer any more, with its fat green monotony, its dry distances, where everything is clearly outlined, its tormenting heat, depression, somnolence. The *sensations* revive in September and October.'

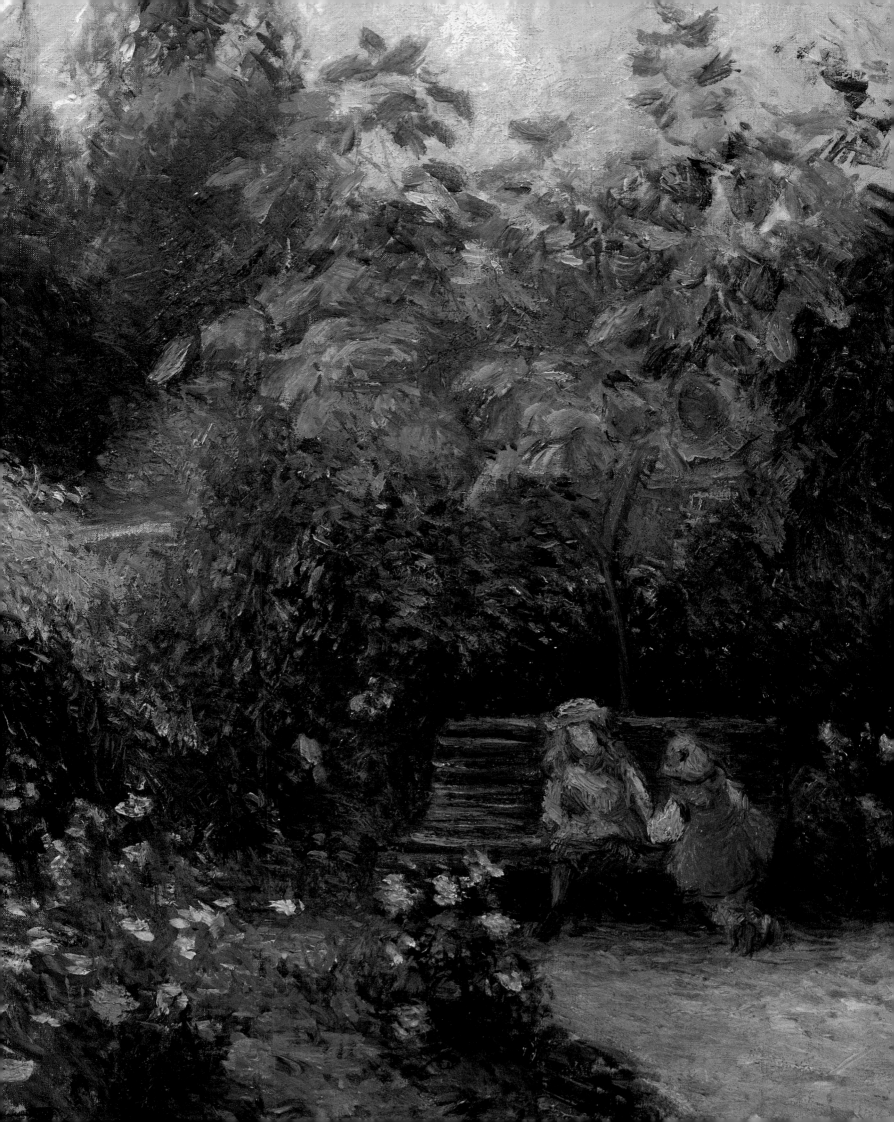

PIERRE-AUGUSTE RENOIR
(1841–1919)

Still Life, Arum and Flowers
1864

Oil on canvas 130.2 × 95.9 cm (51¼ × 37¾ in)
Oskar Reinhart Foundation, Winterthur

Caught up in Monet's enthusiasm for flowers as a subject in themselves—'an excellent thing to paint'—Renoir did two still lifes in the greenhouse. The other less successful version is now in the Kunsthalle in Hamburg. Faced with the challenge of injecting this indoor scene with the same directness as his *plein-air* canvases, he painted it on the spot, pulling the pots into a seemingly casual arrangement. The composition strongly resembles a landscape he might have seen, with bushes massed round a tree and a path running off to one side. In his grouping, the centre is held by the strong stem of an arum lily, its broad spreading leaves occupying the upper space. Round it he has placed a box of pom-pom daisies, and various pots containing tulips, crocus, hyacinth, pelargonium, cineraria, a branch of white lilac and two large tufts of long grass. Apart from helping to anchor the composition, the grass adds a genuine element of earth and garden. Compared to Monet's elaborate and consciously beautiful still life *Spring Flowers* (1864), and one which he thought worth of consideration by the Salon judges, Renoir's is very much the working gardener's assortment, just as he might have chanced upon it in the greenhouse. A few years later Renoir executed a bouquet of spring flowers brushed in with small, delicate touches. But these greenhouse plants, as befitted their humbler setting perhaps, have been handled more robustly. Even so, we are aware of Renoir's unaffected feeling for the textures of different plants and for the way light describes their petals against a dark ground.
As he told Georges Rivière later:
'Painting flowers is a form of mental relaxation. I do not need the concentration that I need when I am faced with a model. When I am painting flowers I can experiment boldly with tones and values without worrying about destroying the whole painting. I would not dare to do that with a figure because I would be afraid of spoiling everything. The experience I gain from these experiments can then be applied to my paintings.'

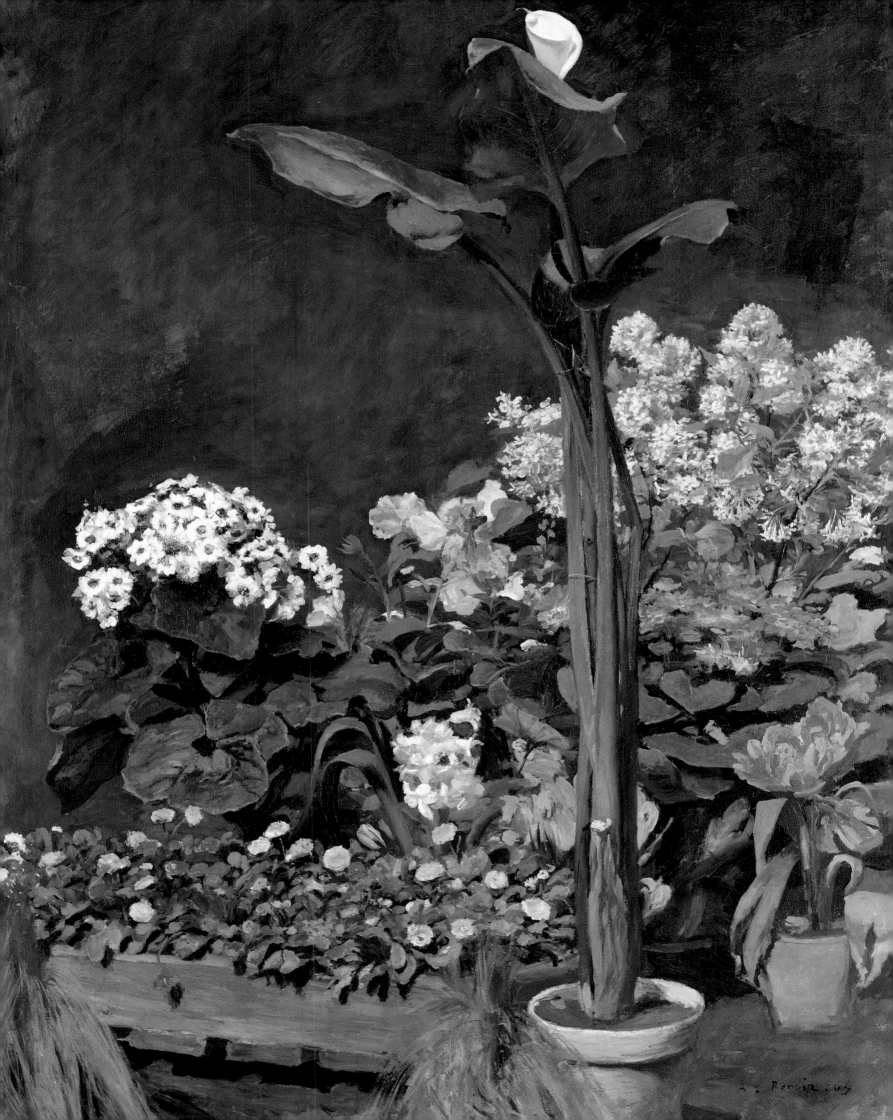

24

CLAUDE MONET
(1840–1926)

The Luncheon
c. 1873–4

Oil on canvas 160 × 201 cm (63 × 79⅛ in)
Musée d'Orsay, Paris

Monet exhibited this large painting as *Decorative Panel* in the second Impressionist exhibition of 1876.
The original title is of some interest. Although Monet was working consistently out of doors in the seventies and eighties, he painted some of his larger canvases in his studio. It is thought that even the experimental *Women in the Garden*, for instance, was partly executed from an upstairs window in the suburban house he rented in Ville d'Avray (Pl. 32). No preparatory studies for *The Luncheon* exist, but if it *is* studio work, as the British authority on Monet, Dr John House, implies, Monet would almost certainly have made use of open-air oil sketches as he did for other decorative work. The canvas would, in any case, have been finished indoors, and it shows Monet's virtuosity in blending improvisation and fantasy to achieve a marvellously painted outdoor effect. The colour of the garden in Argenteuil, the first of Monet's gardens, is eye-catching (see also Pl. 48). Dominant contrasts of bright pigment, most conspicuously red and green, have been dabbed onto the canvas to evoke the textures of fuchsia, geranium and rose. Most memorably Monet makes play with the variations of dappled light as the afternoon sun falls across the garden. In one place it catches the sheen on the women's dresses, or the curve of the silver coffee-pot, in others it illuminates the crown of the hat hanging in the tree, strikes a bright note on Jean's smock or highlights the slats of the wooden bench. As always with Monet, such seemingly random gestures are unified into a magically atmospheric piece of picture-making.

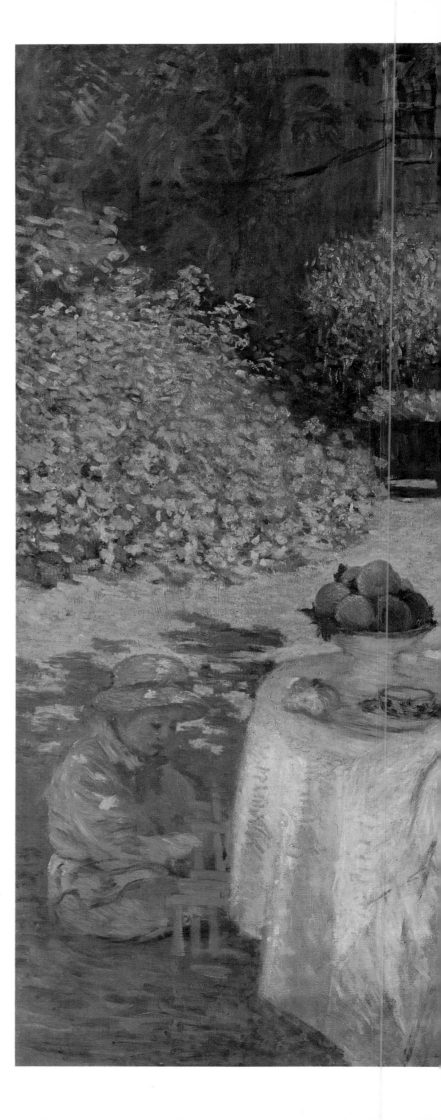

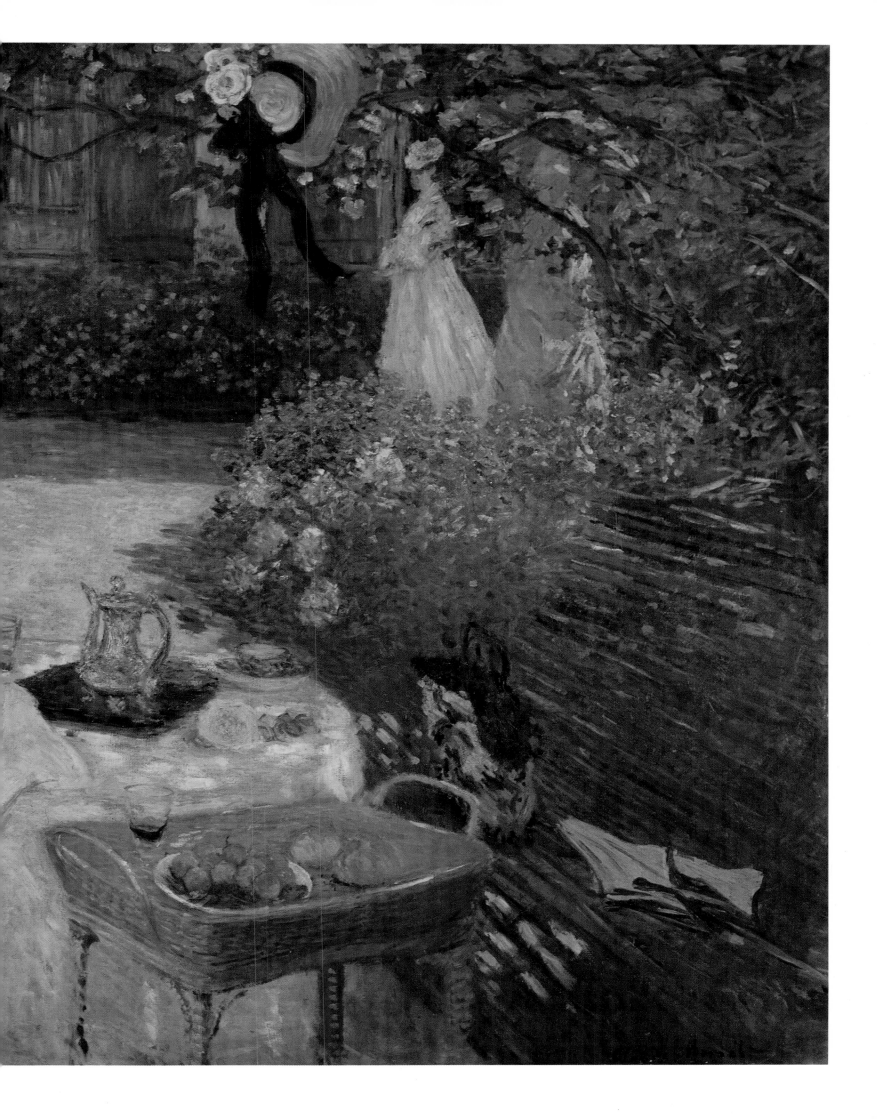

CLAUDE MONET
(1840–1926)

The Garden, Giverny
1902

Oil on canvas 89 × 91 cm (34³/₄ × 36 in)
Kunsthistorisches Museum, Vienna

Monet once said that his only two interests in life were painting and gardens. In Giverny his enthusiasms merged for the last time in the creation of what is perhaps the most famous of all artists' gardens, now painstakingly and beautifully restored. 'My garden is a slow work, pursued with love and I do not deny that I am proud of it. Forty years ago, when I established myself here, there was nothing but a farmhouse and a poor orchard,' Monet told one of his visitors to Giverny. 'I dug, planted, weeded myself, in the evenings the children watered.'

When he moved to Giverny as a tenant in 1883, Monet's first task was to plant it with motifs for painting. In 1890 he purchased the property and, with the help of a gardener, Félix Breuil, and five assistants, he set about transforming the garden into a decorative ensemble that he could translate directly into paint. On one occasion, when he was visiting Bordighera in Italy, he had lamented, 'I would love to do orange and lemon trees silhouetted against the blue sea, but I cannot find them the way I want them.' His design for Giverny produced exactly the juxtapositions of colour that he craved for his art. Such was the effect that Proust observed the flowers were 'arranged in a whole that is not entirely that of nature, since they have been planted in such a way that only those flowers blossom together whose shades match, harmonize infinitely in a blue or pink expanse, and which this powerfully revealed intention on the part of the painter has dematerialized, in a way, from all that is not colour'. The *grande allée*, pictured here, leads up to the house.

Arched over with trellises and lined with nasturtiums, the long walk is characteristic of Monet's delight in luxuriant growth. Although the garden beds were arranged in neat rectangles, every available space was filled to overflowing with colour that would change from one season to the next. The canvas, too, is kept constantly alive with touches of bobbing colour. Monet has translated the individual flowers into palpitating masses, absorbed into an overall play of light and colour he was at pains to perfect. Every hard line has dissolved to produce the colourful mirage that amazed Proust.

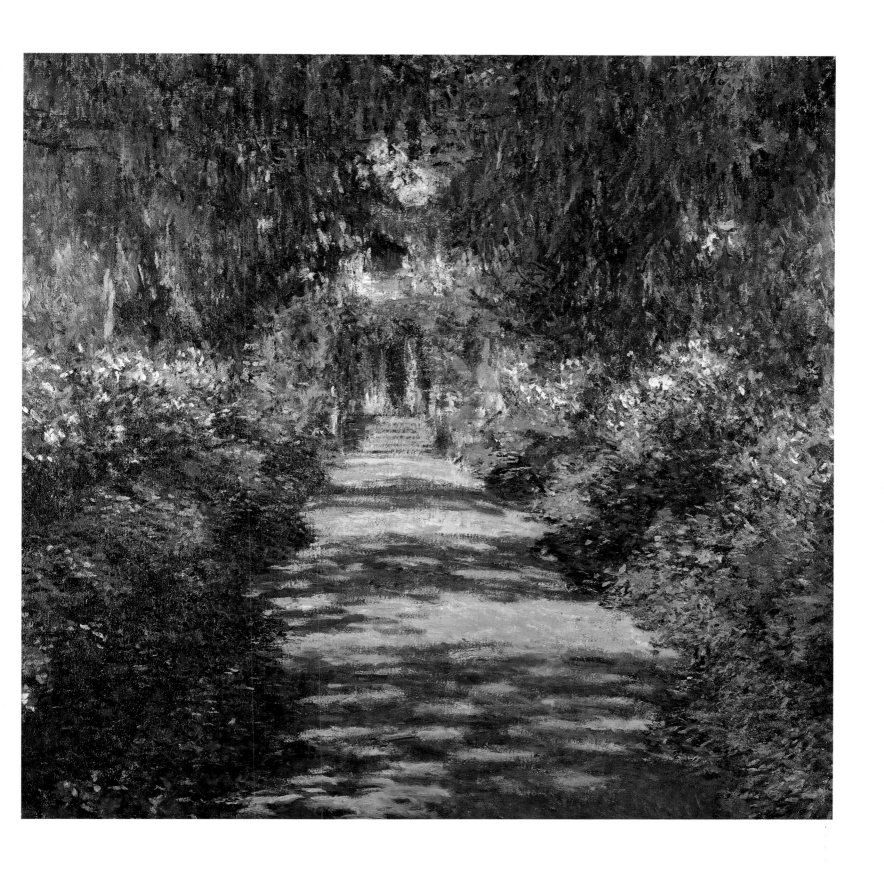

PIERRE-AUGUSTE RENOIR
(1841–1919)

Garden in the rue Cortot, Montmartre
1876

Oil on canvas 153.7 × 97.8 cm (60^1/$_2$ × 38^1/$_2$ in)
The Carnegie Museum of Art, Pittsburgh

'The house in the rue Cortot was falling to pieces but
Renoir did not mind. It provided the advantage of a
large garden, with a magnificent view of the
countryside as far as Saint-Denis. A mysterious
stately garden, like Zola's *paradou*—what was once
part of a fine residence.' In his biography *Renoir, My
Father*, Jean Renoir was describing the studio his
father rented in Montmartre, not far from the Moulin
de la Galette. The property once formed part of a
private park belonging to an eighteenth-century
château, and its associations, as well as its idyllic
rural setting, clearly had strong appeal for Renoir.
From the upstairs windows of the cottage Renoir had
a wonderful view of the overgrown garden, which
became a favourite subject for some of his most
delectable paintings. Visiting friends made
impromptu models. So in this painting Monet and
Sisley, exchanging words at the garden gate, are
swept up and almost totally absorbed into the sylvan
setting. Renoir's raised vantage point compresses the
space and he encloses the end of the garden with the
impenetrable depths of the park beyond. The
isolation of the spot does not even hint at the city
close at hand. The vertical composition is strongly
oriental in conception and Renoir's real subject is
nature: a magnificent clump of dahlias, their
luxuriant vegetation gleaming in the filtered
sunlight, which fills almost half the canvas. The
jewel-like quality of the flowers draws on the richness
of Renoir's pigments: reds, yellows, blues and, above
all, a wonderful range of greens. The colours have
been brilliantly marshalled and then dispersed in
sparkling fragments over the canvas to evoke the airy
ambience of the sunlit garden and its ambiguous
perspective.
Later Renoir moved to another rambling garden in
the rue Girardon. 'All along our fence there were
rose-bushes which had reverted to their wild state.
Just beyond was an orchard belonging to old Gries,
one of the last market-gardeners on the heights of
Montmartre,' Jean reminisced. 'For most Parisians
this little paradise of lilacs and roses seemed like the
end of the world.'

27

CLAUDE MONET
(1840–1926)

Terrace at Sainte-Adresse
1867

Oil on canvas 98 × 130 cm (38½ × 51¼ in)
The Metropolitan Museum of Art, New York

'I am in the bosom of my family,' Monet wrote to his friend Bazille on 25 June 1867. 'My work is cut out for me: I have a good twenty canvases under way—dazzling seascapes and figures and gardens.' The letter he sent from his parents' home in Sainte-Adresse expressed Monet at his happiest. Sainte-Adresse was a fashionable resort along the Normandy coast from Le Havre, where he had spent his childhood. The place and scene were very familiar to him and *Terrace at Sainte-Adresse* epitomized his current preoccupation with painting informal scenes of everyday life.

The picture shows his father and other figures enjoying a sea view from their private terrace. The amenities were probably typical of many such villas: a high excluding fence, a private mooring point for one of the boats dotting the horizon, a paved area for sitting and colourful, well-tended flowerbeds and borders. Monet has realized the strong afternoon glare in harshly contrasting patches of sunlight and shadow. The sparkling sensation he drew from the scene is captured by an audacious use of vibrant colours. In particular, the reds of the gladioli and geraniums and the vivid colours of the nasturtium, which have been touched in among a mass of green foliage and expanses of purplish shade, give an electrifying charge to an otherwise uneventful scene of middle-class leisure.

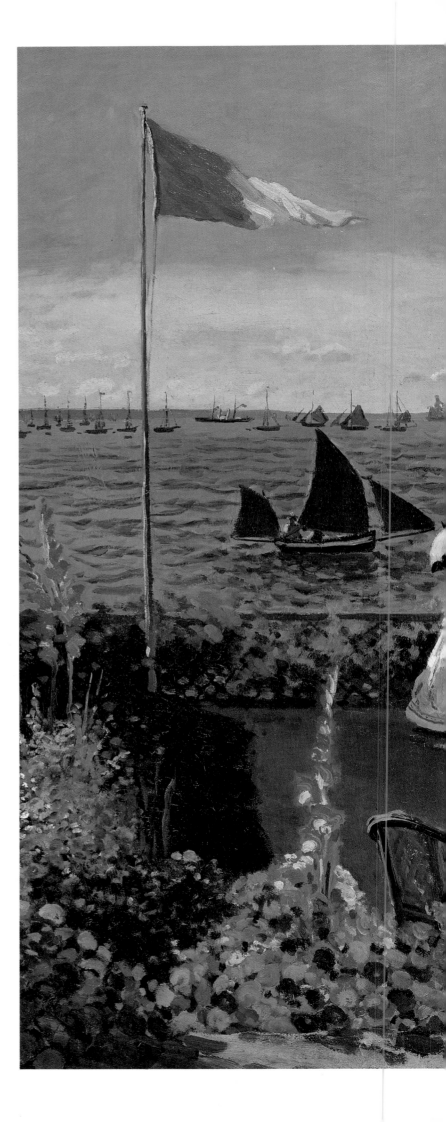

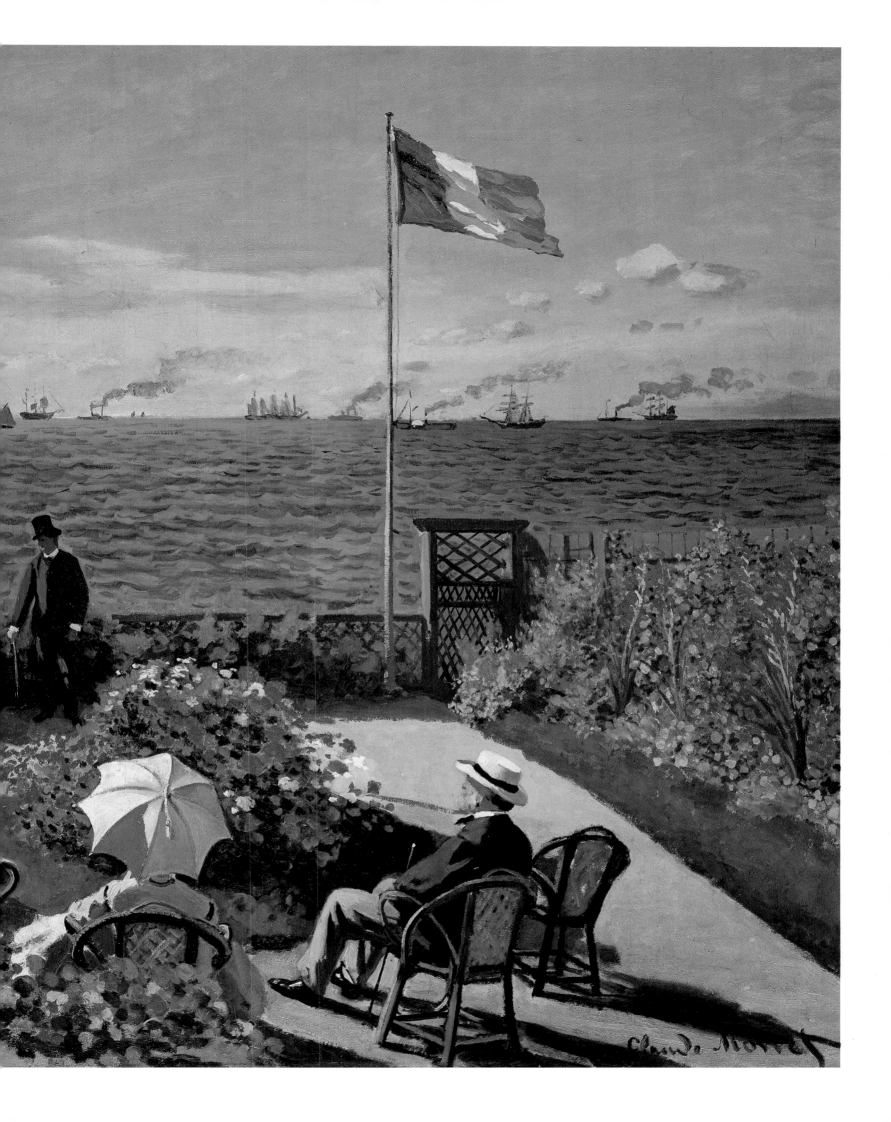

PIERRE-AUGUSTE RENOIR
(1841–1919)
Still Life with Bouquet
(detail) 1871

Oil on canvas, 74.9 × 59 cm (29½ × 23¼in)
Museum of Fine Arts, Houston

Of all the many paintings Renoir made of roses
during his life this is one of his loveliest. His brush
seems almost to have fondled the half-open blooms
into being and then touched them with light
reflected off the dazzling bonnet-like surround.
Viewed head-on, in a densely packed cluster of
some two dozen stems of yellow and red roses frilled
with lacy white lilac, the shape and colours of
the bouquet echo the palmetto fan lodged in the
Japanese vase beside it. A symphony of red, gold
and black, the painting is strongly oriental in mood.
Renoir, as we know from his own observations,
admired the Japanese approach to the natural world:
'The Japanese still have a simplicity of life which
gives them time to go about and to contemplate.
They still look, fascinated, at a blade of grass, or the
flight of birds, or the wonderful movements of fish,
and they go home, their minds filled with beautiful
ideas, which they have no trouble in putting on
the objects they decorate.'
The loose paper wrapping gives Renoir's bouquet
something of the billowing, free-flowing nature
of the oriental poppies painted on the fan. Worked
up quickly and directly from a few gestures of rich
creamy impasto paint, Renoir has given us flowers
fit for our contemplation.
There is an air of suspense about this mysterious
bouquet, still unwrapped, which recalls the bunch
of flowers presented to *Olympia* in Manet's painting,
and the image must have been in Renoir's mind.
The print on the wall behind is also by Manet,
copied by him from a painting in the Louvre
which was thought at the time to be by Velázquez.
Renoir painted *Still Life with Bouquet* as a tribute to
Manet, whose portrait of Zola is also referred to here.
Together, the different elements of the composition
can be read as a celebration of 'modern life'.

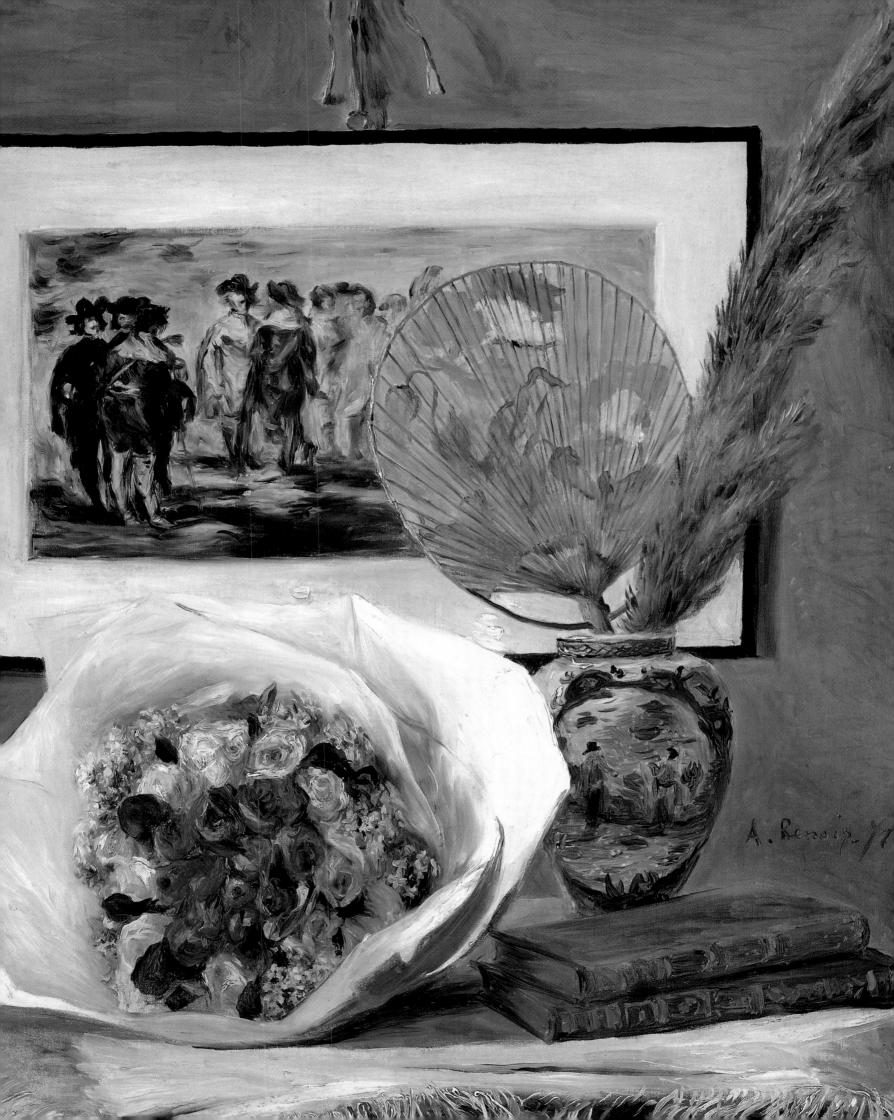

EDOUARD MANET
(1832–83)
The Monet Family in their Garden in Argenteuil
1874

Oil on canvas 61 × 87 cm (24 × 34¼in)
The Metropolitan Museum of Art, New York

It was Manet who found the Monet family their home in Argenteuil. A little way out of Paris along the Seine, it lay opposite the Manet family residence at Gennevilliers on the south bank of the river. Renoir became a frequent visitor there, painting the same motifs as Monet and portraying his friend at his easel in the garden (Pl. 3). In the summer of 1874 Manet joined them for a few weeks, and one day, 'beguiled by the colour, the light', was persuaded to continue his own experiments outside, using the lighter, brighter colours of his companions to convey the summer atmosphere. A painter of superb floral still lifes, Manet did not enthuse about flowery gardens. His subject was figures in the open and he concentrated on trying to integrate them in a natural setting. Here he paints an informal family scene: Monet's wife Camille seated in partial shade under a tree, their first son Jean stretched lazily on the grass beside her, Monet with his watering can attending to a plant (see also detail, Pl. 19), while a cock, hen and chick run around them. Compared to Monet's explosive handling of colour at this time (title page), Manet's painting remained generally low-keyed. Camille's white dress and the accents of bright red and blue make telling moments in a garden of subdued greens and earth colours. The figures are unposed and Manet's realism has caught the drabness of this formless, unkempt corner of the garden. Unlike Monet and Renoir, Manet preferred a garden that displayed structural order, or at least one on which he could impose it pictorially. Taking a cure at Versailles in 1881, he expressed his intention of making 'studies of the garden designed by le Nôtre'. His attempts were foiled because of weeks of unending rain, and he complained that 'I have had to content myself with simply painting my garden, which is the most horrible of gardens.' We know from his nonetheless attractive depiction of it, that the garden had gone entirely to seed – and that Renoir and Monet would have made much more of its rampant colour.

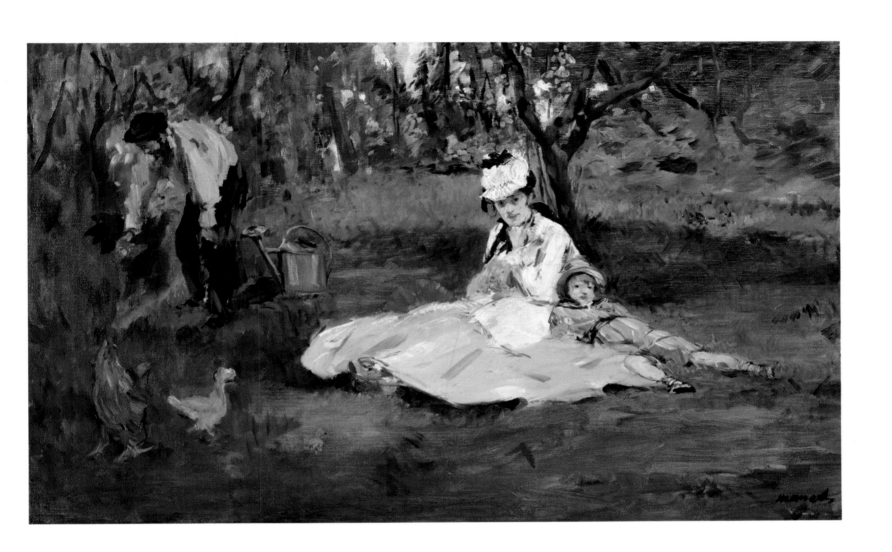

31

FREDERIC BAZILLE
(1841–70)

Terrace at Méric
(detail) 1867

Oil on canvas 56 × 98 cm (22 × 38½ in)
Cincinnati Art Museum

When Bazille knew Méric, the old sixteenth-century property was planted with flowering shrubs and trees, ornamental flowerbeds and roses clambering the house walls, and its familiar beauty attracted him as a subject. The house was situated not far from the Bazilles' home in Montpellier and it made an ideal summer residence. It was built on the promontory of a hill, and the family enjoyed a superb view from a broad terrace down into the valley of the River Lez and across to the village of Castelnau. Here, during boyhood holidays in the Languedoc countryside, Frédéric Bazille developed his profound love of nature.

In the sixties he was studying in Paris, first towards an abortive career in medicine, and then in fulfilment of his wish to become an artist. He kept in affectionate touch with his parents and would always return south for the summer. In 1866 and 1867, he painted a number of oils on the terrace at Méric. The largest, which he referred to as 'my Méric picture', showed his family gathered under the shade of the flowering chestnuts. For the painting illustrated here he selected a sunny corner of the terrace near the house. 'The cicadas chirp stridently nearby, and the sun creates infinite clouds of dust,' he wrote. In his paintings he brought the sharpness and clarity of the Mediterranean light to bear on his definition of form.

Characteristically and under Monet's influence, Bazille has divided the picture into two areas. The foreground is warmly shaded by a chestnut bedded in flowering vegetation; the brilliantly lit background, with its bushes of oleander, gives full scope to Bazille's spectacular handling of colour. The result is a clamour of pinks, jostling one another for a place in the sun. Finally, though, it is the stillness of the heat and the timelessness of Méric that Bazille captured so well. A year later, he wrote to his friend Edmond Maître: 'I should like to restore to each object its weight and volume, and not simply to paint the appearance of things.'

(Previous Plate)

30

CLAUDE MONET
(1840–1926)

Paysage: Parc Monceau, Paris
1876

Oil on canvas 59.7 × 82.6 cm (23½ × 32½ in)
The Metropolitan Museum of Art, New York

See Plate 42

CLAUDE MONET
(1840–1926)

Women in the Garden
1866–7

Oil on canvas 256 × 208 cm (100³/₄ × 81⁷/₈ in)
Musée d'Orsay, Paris

There is no doubt that the expansion of city life into the Parisian suburbs, and the novelty of owning a plot of ground, encouraged a craze for gardening among the middle classes. Monet, it has been said, crystallized this image of the bourgeois garden, not just as a pretty place, but as a social arena for fashionably dressed women dallying in the sunshine. Their beauty was complemented by flowers, and in particular by roses, which, at the period, were still a conventional attribute of feminine charms. The young women in Monet's canvas were not just attractively elegant. Their wide-skirted dresses were the height of fashionable modernity.

The inspiration for *Women in the Garden* derived from eighteenth-century pictures of aristocratic leisure in the countryside. Rococo artists such as Watteau had been popularized by the Romantics, and Monet reinterpreted their themes in a recognizably modern context. His attempt early in 1866 in *Déjeuner sur l'herbe* to work up a painting of a woodland picnic from outdoor studies remained unfinished. Turning to a more accessible setting, he wrestled with the problem of portraying large-scale figures directly in the open air. In spring of the same year, he rented lodgings in the Ville d'Avray, a suburb of Paris near Sèvres. There in the garden he dug a trench into which he lowered a canvas over eight feet high (nearly three metres) so that he could work on it outside. Camille Doncieux, later to become his wife, was his model. The procedure was entirely novel and although Courbet teased him for idling when the sun went in, the effects Monet procured from his immediate observations must have struck his friends as, quite literally, dazzling. Large expanses of barely shaded white dress and dramatic contrasts between areas of sun and shadow heightened the impression of brilliant light. Monet later softened the hard lines produced by bright sunshine as he responded to more atmospheric moods in nature.

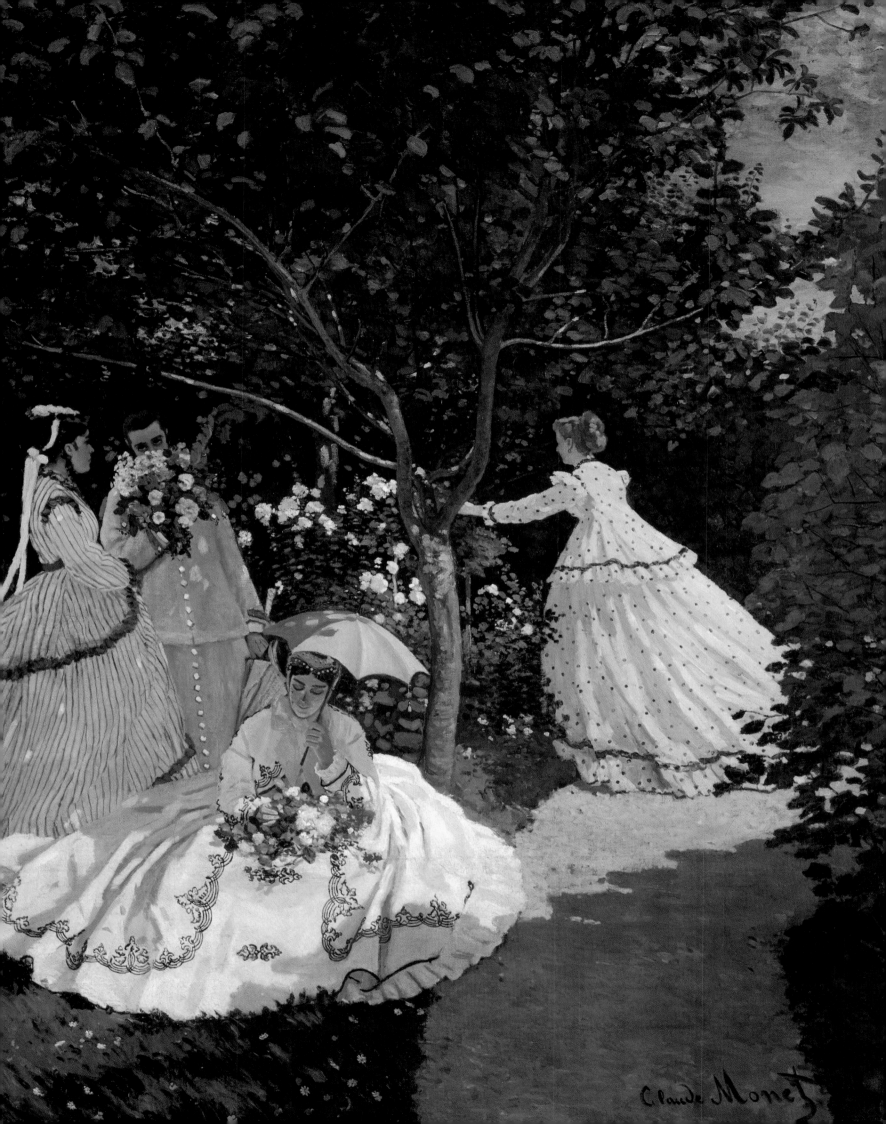

33

FREDERIC BAZILLE
(1841–70)

Flower Pots
1866

Oil on canvas 97 × 88 cm (38$^{1}/_{8}$ × 34$^{5}/_{8}$ in)
From the Collection of Mrs John Hay Whitney

This is one of Bazille's most beautifully rendered colour harmonies. Composed of seven or eight pots of flowers and a bouquet of roses, in differing shades of pink, white, blue and red, it was painted at his family's summer seat in Méric. In the letters he sent home from the capital Bazille would refer longingly to these flowers. 'The greenhouse must be very pretty,' he wrote to his father.
While in Paris, Bazille studied with Monet, Renoir and Sisley in the studio of Charles Gleyre, who, unlike other academic artists, encouraged his pupils to paint still lifes of flowers. This composition of common flower pots resembles the one Renoir painted in 1864 at Monet's instigation. The more elaborate console arrangements that Bazille painted at Méric a few years later recall the deep, richly coloured flower-pieces of Courbet and early Monet. Bazille was never wholeheartedly Impressionist.
When he went south, he continued to work spontaneously from the motif, responding to the way the harsh light there delineated contours and detached forms dramatically from their surroundings.
He was rarely content with a snappy notation, preferring to render the object in front of him as a palpable and solid image. From the sensitive drawing of plants in this still life, it is clear that Bazille had a great feeling for flowers which he was never able to develop. Enlisting in the Franco-Prussian war in 1870, he was killed the same year.

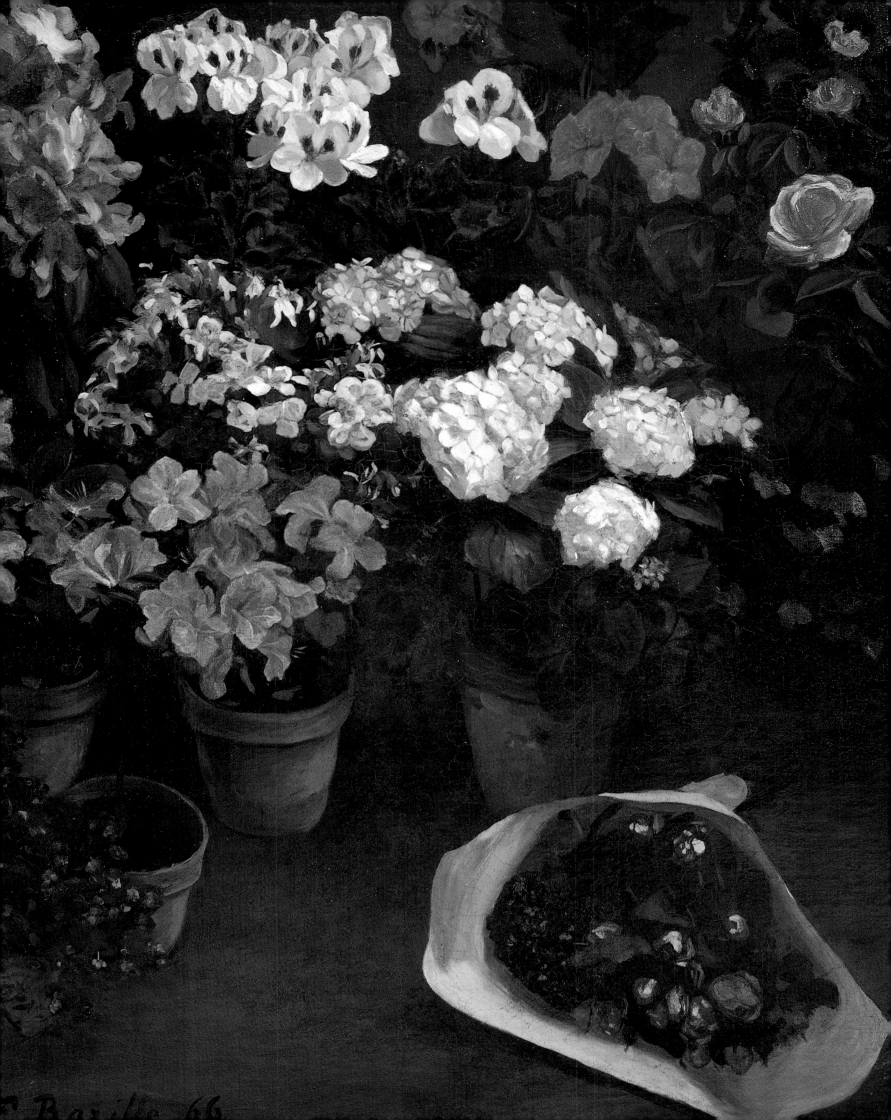

GUSTAVE CAILLEBOTTE
(1848–94)

Roses, Garden at Petit-Gennevilliers
c. 1886

Oil on canvas 89 × 116 cm (35 × 45⅝ in)
Private Collection, Paris

The woman admiring a rose in Caillebotte's sun-drenched garden in Petit-Gennevilliers was his companion, Charlotte Berthier (see also detail, Pl. 11). Conventionally, rose trees graced portraits of society beauties, the sort of sentimental studio work with which Auguste Toulmouche won a reputation. For Caillebotte the scene was part of the flow of daily life in his large garden. The lap-dog is an amusing detail, but it sits with its back to us. It doesn't pose and it doesn't distract attention. Caillebotte has caught the informal spontaneity of the occasion with some success, dashing in the soft earth with a flurry of coloured strokes. But he lingered over his description of the roses, not wanting perhaps, as a rose specialist, to lose the softness of their features in a glare of Impressionist light effects.

Since early in the century the area had been a centre of rose culture, made fashionable by the Empress Josephine. Caillebotte was a man of substantial private means, and in Petit-Gennevilliers he could afford to indulge his three passions, for painting, flowers and boats. He acquired the house and its extensive ornamental and kitchen gardens in the early eighties and from then on based his experiments in light and colour on flowers from his garden. Caillebotte was one of the new breed of private gardening enthusiasts, and his devotion to cultivating the property equalled Monet's at Giverny.

His interest was clearly more than an amateur's. Photographs show him with an assistant among his immaculately ordered beds of seedlings. Close to the house he constructed a large greenhouse in which he cultivated orchids and other tender species. And as at his family home, Yerres, there was a rose garden. Caillebotte did numerous canvases in the garden of Petit-Gennevilliers: paths and flowerbeds, masses of dahlias, roses, chrysanthemums, sunflowers, poppies, iris and hyacinth borders. On his death the painting 'still wet on the easel' was one of the garden.

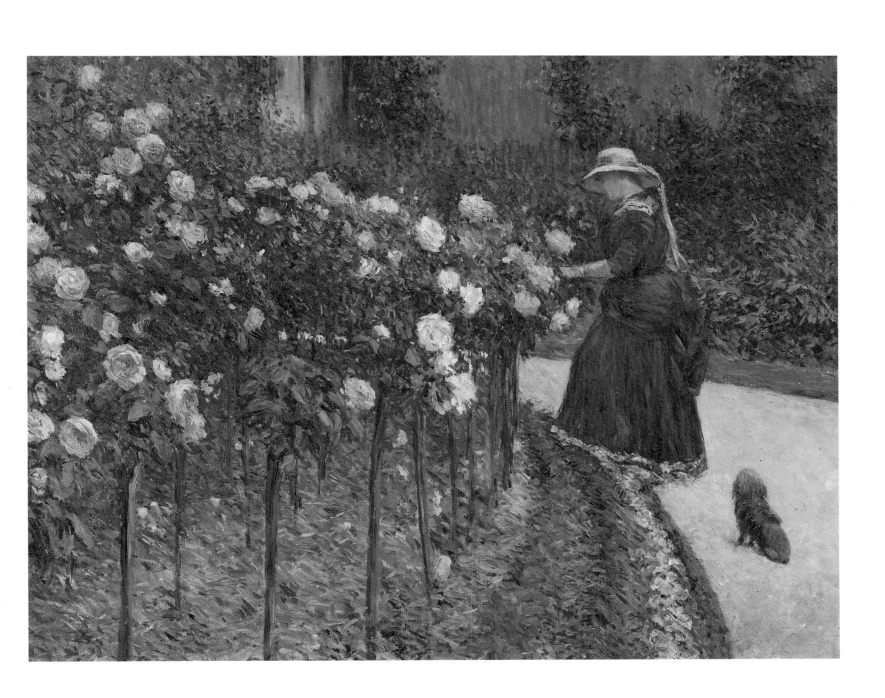

CAMILLE PISSARRO
(1830–1903)

The Wheelbarrow
(detail) *c*. 1881

Oil on canvas 54 × 65 cm (21$^{1}/_{4}$ × 25$^{5}/_{8}$ in)
Musée d'Orsay, Paris

'Pissarro's peasants work to earn their daily bread,'
Degas said in response to Pissarro's pictures of rural
life. The central image in this painting is a traditional
wheelbarrow—one peasant's essential working tool,
as anonymous as its owner, and, at the same time, an
emblem of the land. The location is undefined, for
Pissarro's countryside is an interlocking medley of
kitchen gardens, cabbage fields, orchards and strips
for making hay. It is a terrain shared by pigs and
chickens and a donkey or two, in which the labour of
humans and animals blend harmoniously with the
soil. Pissarro knew its reality intimately, and he
described it with truthfulness and affection, in what
may be regarded partly as a hymn, partly as a song of
toiling. The manner in which he has framed the
unknown woman within a Gothic arch shaped by two
trees suggests an almost reverential approach to
nature. In 1894, when he was having difficulty in
selling his work on account of his humble subject-
matter, he demanded: 'What would the Gothic
artists say, who so loved cabbages and artichokes and
knew how to make of them such natural and
symbolic ornaments?'
'One can make beautiful things with so little,' he
wrote on another occasion to his son Lucien. 'Old
Corot, didn't he make beautiful little paintings in
Gisors, two willows, a little stream, a bridge. . .
Everything is beautiful, the whole secret lies in
knowing how to interpret.' Pissarro's interpretation
has the rough strength of coarsely woven hessian or
tweed, and the English, according to Pissarro, found
his work 'uncouth'. 'Remember that I have the
temperament of a peasant, I am melancholy, harsh
and savage in my works,' he explained. From the
depth of these emotions and from the close
observation that characterized Impressionism Pissarro
produced a great pastoral cycle.

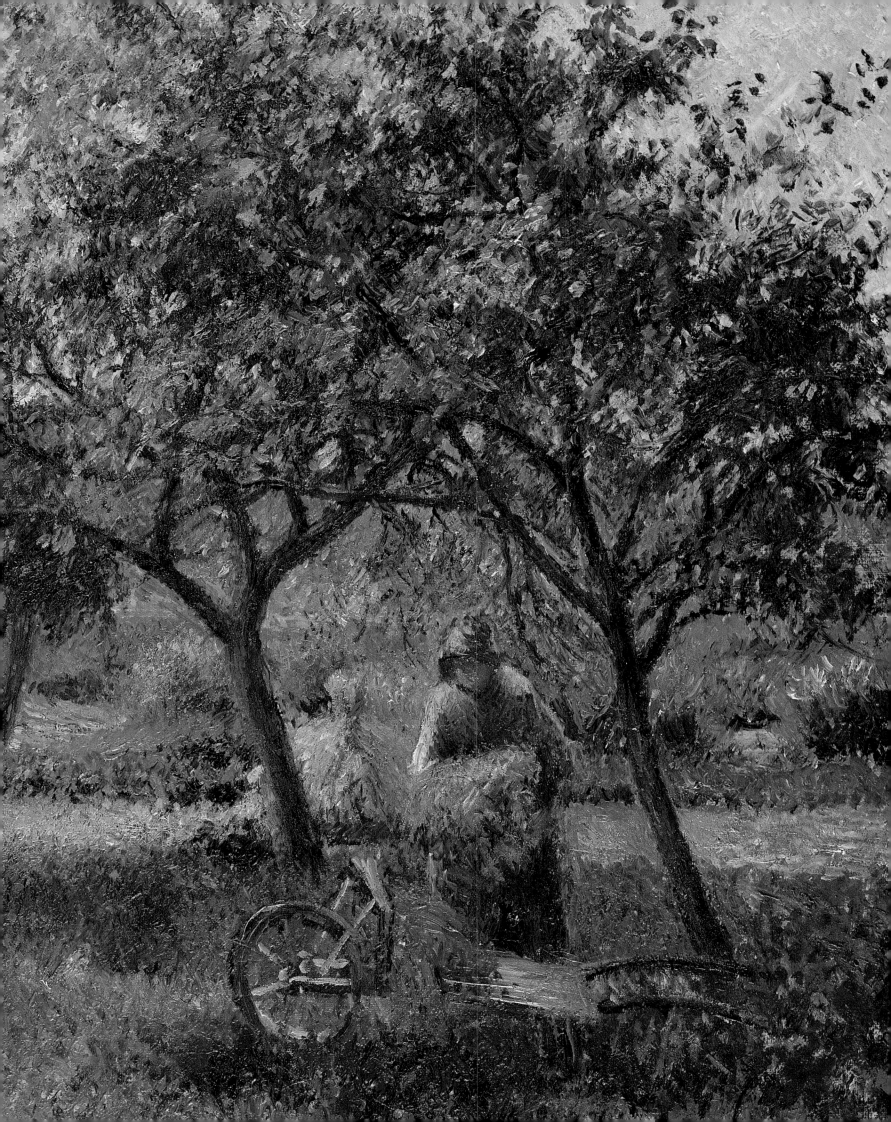

PIERRE-AUGUSTE RENOIR
(1841–1919)

The Railway Bridge at Chatou
(detail) 1881

Oil on canvas 54 × 65.7 cm (21$^{1}/_4$ × 25$^{7}/_8$ in)
Musée d'Orsay, Paris

The railway bridge over the Seine at Chatou was a
sign of the new age of travel and leisure. When the
line was opened in 1841, Chatou became easily
accessible from the Gare Saint-Lazare in Paris. As a
centre for rowing, it became increasingly popular
with sportsmen when towns nearer Paris became
overwhelmed by a crush of visitors and metropolitan
settlers. A contemporary writer, Adolphe Joanne,
noted that even in Chatou, which was some way
downstream from Argenteuil, large estates were being
carved up to provide land for elegant summer villas.
Pockets of natural beauty were still to be found,
particularly on the islands that divided the Seine into
two channels south of Argenteuil. On one of these,
Chiart Island, Renoir painted his picturesque 'tourist'
view of the bridge from a private, fenced-in garden.
The chestnuts, pink and white, are in full and
glorious flower. A light breeze dishevels grass, leaves
and sky. A figure standing in a gap in the fence draws
our eye through to the rippling light on the river
beyond. Nature and man, nature and 'progress' are, it
seems, in perfect harmony. All this Renoir has
woven together instinctively with his brush in a
virtuoso piece of tapestry-making.
Not long afterwards Renoir was to move away from
atmospheric painting in the open air, explaining to
the art dealer Ambroise Vollard that 'out of doors
there is much greater variation in the light than in
the studio where it is always steady, but you see,
outside you are caught by the light; you have no time
to think about composition and, another thing, you
can't see what you are doing.'

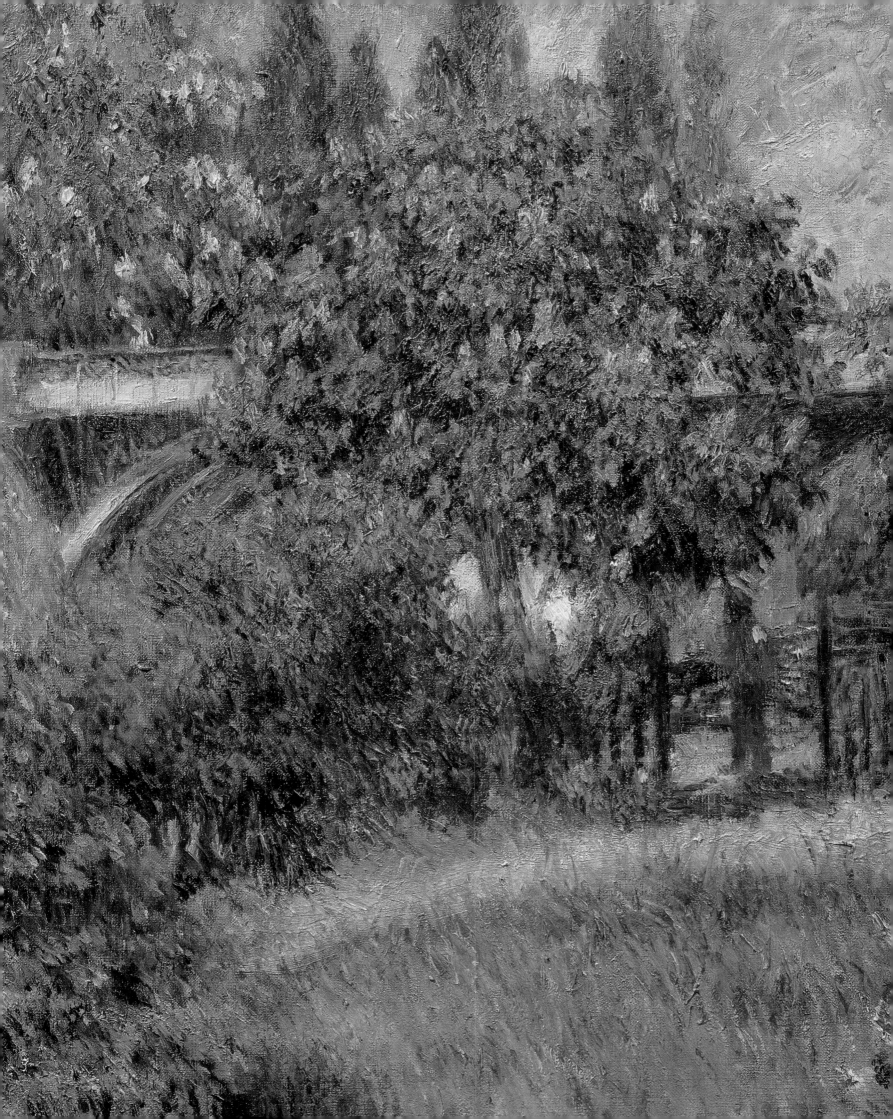

CLAUDE MONET
(1840–1926)
Japanese Bridge at Giverny
c.1900

Oil on canvas 89.8 × 101 cm (35⅛ × 39¼in)
The Art Institute of Chicago

In 1893, a few years after acquiring ownership of the
property at Giverny, Monet purchased a small pond
fed by the river Ru, which he embellished as a water
garden. Branches of weeping willow and silver birch
hung over the water, grasses grew along undulating
banks and the pond itself was planted with varieties
of water lily. A green wooden footbridge spanning it
was inspired by those he had seen in Japanese prints.
The lily pond was originally conceived as 'something
for amusement and for the pleasure of the eyes',
Monet said. 'It took me some time to understand my
water lilies. I planted them for pleasure; I cultivated
them without thinking of painting them.' By the
winter of 1895 he was already at work on the motif
of the bridge, developing his ideas the following
summer into his first great series of water lily
paintings. The site was small but, by shifting his
position gradually to the left for each painting,
Monet could use the arc of the bridge to frame
a different perspective of the pond as he observed
it by changing light and weather.
The reflective qualities of water surfaces, on the sea
and on rivers, had always intrigued him, and these
ambiguities were rendered even more complex and
mysterious at Giverny, where the water offered a still
surface, at once mirror-like and transparent. With
his easel and canvases at the water's edge he could
study the play of natural colours and textures among
the floating plants and among the fall and froth of
overhanging trees as their foliage mingled strangely
with the submerged vegetation. In the painting
reproduced here Monet's continuing concern with
colour harmonies prompted a strong emotive
response. Foliage and flowers, seen in magical, silvery
light, are transformed into glittering greens, blues,
pinks and yellows.
Monet's familiarity with water lilies and other
exotic-looking plants depicted by Japanese artists
confirmed his own profound feelings for nature.
He owned a large collection of Japanese prints
himself, including Hokusai's series of large flowers.
'Thank you for having thought of me for the
Hokusai flowers,' he wrote to the dealer Maurice
Joyant in 1896. 'You don't mention poppies, and
that is the most important, since I already have the
irises, the chrysanthemums, the peonies and the
convolvulus.' The fact that Monet grew these plants
emphasizes the closeness of his sensitivities
as artist and gardener.

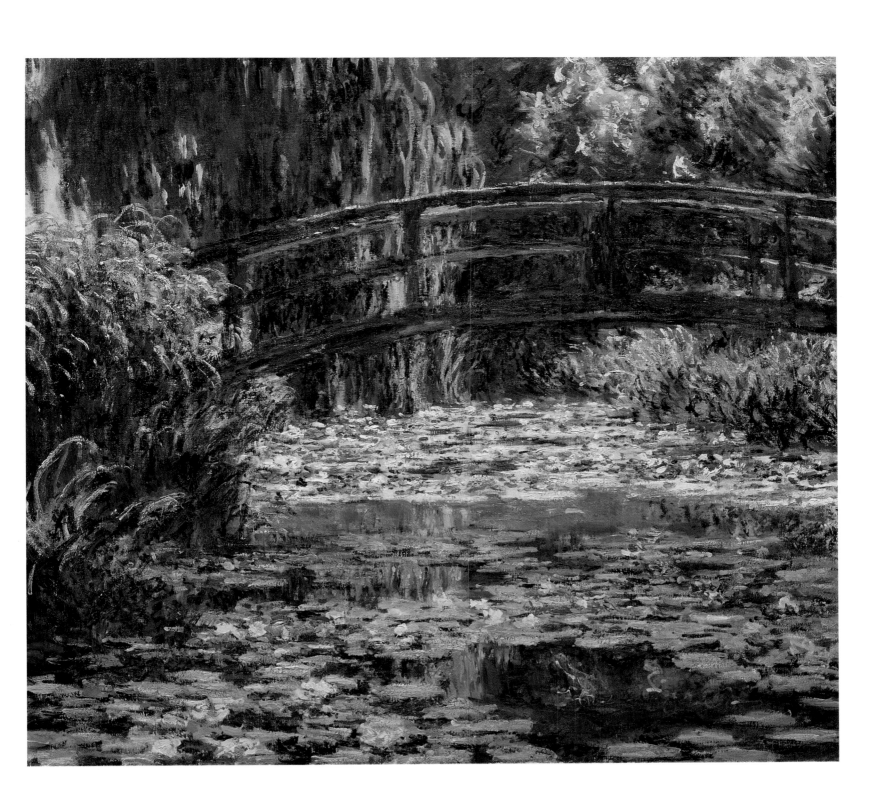

CLAUDE MONET
(1840–1926)

The Japanese Bridge
1923–5

Oil on canvas 89.5 × 116.5 cm (35^1/$_8$ × 45^3/$_4$ in)
Minneapolis Institute of Arts

The colour contrasts Monet employed in his first
paintings of the Japanese bridge became more
theatrical and unnaturalistic as his eyesight failed.
Despite operations for cataract in 1923, he was forced
to compensate for blurred vision by exaggerating his
perceptions. Dramatic natural effects and extreme
weather conditions of snow and ice, storms at sea or
blinding effects of light held him spellbound. He saw
their pictorial possibilities much as Hokusai had seen
and exploited the ornamental effects of a crashing
wave. In this painting, one of a sequence, the
elemental forces of nature take over, rendering water,
air and vegetation incandescent with light. The
bridge, which had been vaulted with a trellis as part
of Monet's improvements to the pond in the early
years of the century, was completely smothered in
wisteria, its twisting stems reinforcing the agitated
rhythms engulfing the scene. As the series progressed
Monet's brush wove increasingly complex patterns
that bore no relation to the contours of the bridge,
the hanging tree fronds or the aquatic plants. All
disintegrated in a commotion of marks.
The geometry of the bridge that dominated the
earlier paintings gives way in this picture to a simple
opposition between the weight of the leaning tree on
the right-hand side, and the forceful thrust of the
bridge from the left. They meet in an explosion of
splintered light, whose rainbow fragments illuminate
every area of the canvas. Never a literal interpreter of
nature, Monet confronted his feelings about it in his
late paintings with a highly keyed, highly charged
vocabulary. Extracting the essence of the place as he
experienced it at a particular moment in the day, he
transformed his impressions according to his own
moods of heightened sensitivity.

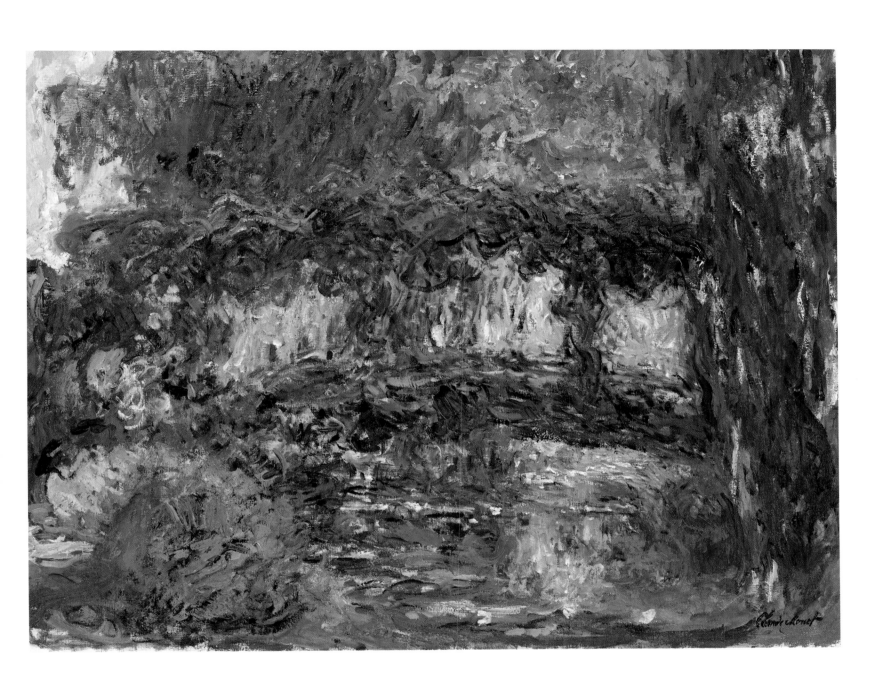

39

VINCENT VAN GOGH
(1853–90)

The Garden of the Poets
1888

Oil on canvas 73 × 92 cm (28³/₄ × 36¹/₄ in)
The Art Institute of Chicago

The public garden in Arles was immediately opposite
Van Gogh's Yellow House. It became the scene of
one of his most striking and passionately painted
series in which he tried over a period to familiarize
himself with a particular place and to capture its
essence. He first mentioned the garden as 'a new
motif' in a letter to his brother Theo in July 1888.
After making several studies of it on the spot, he
wrote again on 17 September describing 'a piece of
the garden with a weeping tree, cedar bushes shaped
into balls, a bush of oleander . . . the same piece you
received a sketch of in my last letter. But much
larger, with a lemony sky above it all, and the colours
now have the richness and intensity of autumn.'
Explaining what he meant by 'the garden of the
poets', he said: 'The garden has an odd feeling about
it. You could easily picture Renaissance
poets—Dante, Petrarch, Boccaccio—tripping
through the bushes and succulent grass.' It became
clear that the garden was really dedicated to Paul
Gaugin, whose arrival he eagerly awaited and whom
he expected to be 'the new local poet'. In his
imagination this perfectly ordinary garden has
been endowed with intensely personal and
symbolic meaning.

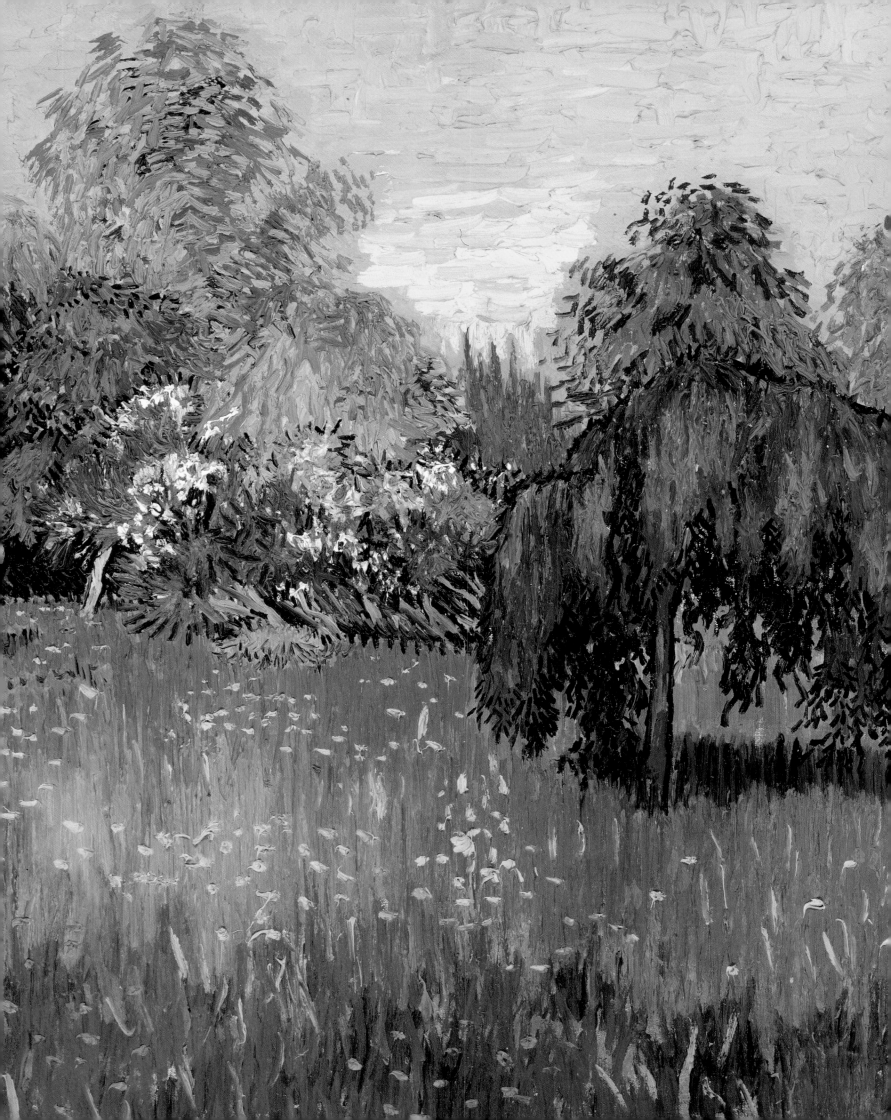

40

PIERRE-AUGUSTE RENOIR
(1841–1919)

Chrysanthemums
(detail) 1882

Oil on canvas 54.6 × 66 cm (21$^{1}/_{2}$ × 26 in)
The Art Institute of Chicago

Renoir painted these white and yellow
chrysanthemums life size and at speed. He clearly
relished every curl of their loose and irregular,
sometimes thread-like, petals. 'The segments of an
orange, the leaves of a tree, the petals of a flower, are
never exactly identical,' he said, formulating a new
aesthetic in defence of 'irregularity' and the beauty of
handcraftsmanship in a machine age. 'It would seem
that every type of beauty derives its charm from
its diversity.'
The object central to this exuberant diversity was a
brown earthenware container in which the flowers
were placed on a table. The selected detail
reproduced here provides an opportunity to admire
the painting purely as a piece of decoration and to
compare it with Caillebotte's rendering of a clump of
the same plant in growth (see jacket). As paintings of
chrysanthemums, both pictures are tours de force and
are especially interesting for what they reveal of two
different artistic personalities.
Renoir has described the petals entirely with the
brush in thin, wet into wet washes on a white
ground. Here and there with a mere flick of paint he
brings an individual petal into closer focus. The
painting is suffused with light from within, and his
colour harmony of yellow and orange-red, white and
mauve reinforces its luminosity. Renoir's use of a fine
canvas and his habit of exploiting the white ground
in the finished painting contribute to the fragile
translucency of the petals. They also remind us of
Renoir's apprenticeship as a decorator of porcelain.
His dexterity and sureness of touch, which years later
enabled him to continue painting even when his
hands were crippled stiff with arthritis, are brilliantly
in evidence. The chrysanthemum heads are brushed
in with the fluency of watercolour. This, too, is a
reminder that Renoir was trained in a craft which
allowed no room for error.

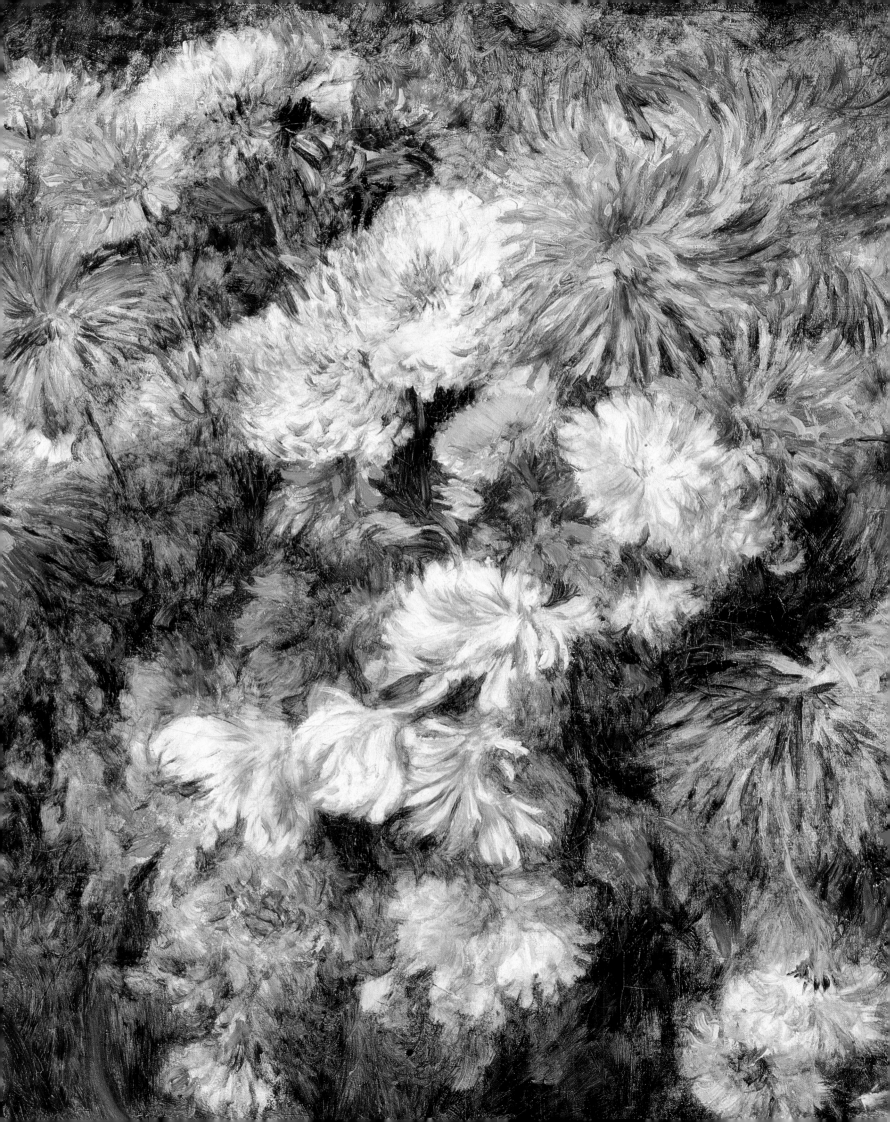

41

PIERRE-AUGUSTE RENOIR

(1841–1919)

Two Sisters (On the Terrace)

1881

Oil on canvas 100.3 × 81 cm (39½ × 31⅞in)

The Art Institute of Chicago

In the serenely happy relationship between two sisters there is more than a hint of Renoir's search for earthly paradise. The setting is a peaceful stretch of the Seine at Chatou, viewed on a sparkling spring day. The two sisters, their backs to the rowing, pass the time on one of the pretty garden terraces which sprang up round cafés in the new river resorts. The naturalism and naturalness of the scene echo Zola's stated belief in 'the eternal joys, the eternal youth of the open air'. Renoir has caught the freshness of the season, but he has also registered its fugitiveness with sprig-like dabs of green and splashes of white. The blurred textures that weave trees, water, boats and sky into one continuous, diaphanous fabric, concentrate all our attention on the charming presence of the two figures. The younger girl meets our gaze wide-eyed, the other casts her eyes shyly along the terrace to some activity out of our sight.

The gentle quality of the weather is in striking contrast to the dominant reds and blues used on the figures, and the energetic diagonals on which the composition is built. The scene is marvellously alive. And yet the flowers worn by the two sisters, the balls of wool piled in the basket on the older girl's knees, and the trailing stem of a creeper, could be taken as elements in a contemporary *vanitas*. Renoir, the Impressionist, would never have toyed with such emblematic treatments of spring. 'What seems to me to be one of the most important things about our movement is that we have freed painting from the tyranny of subject-matter. I am free to paint flowers and call them flowers, without having to weave a story round them.'

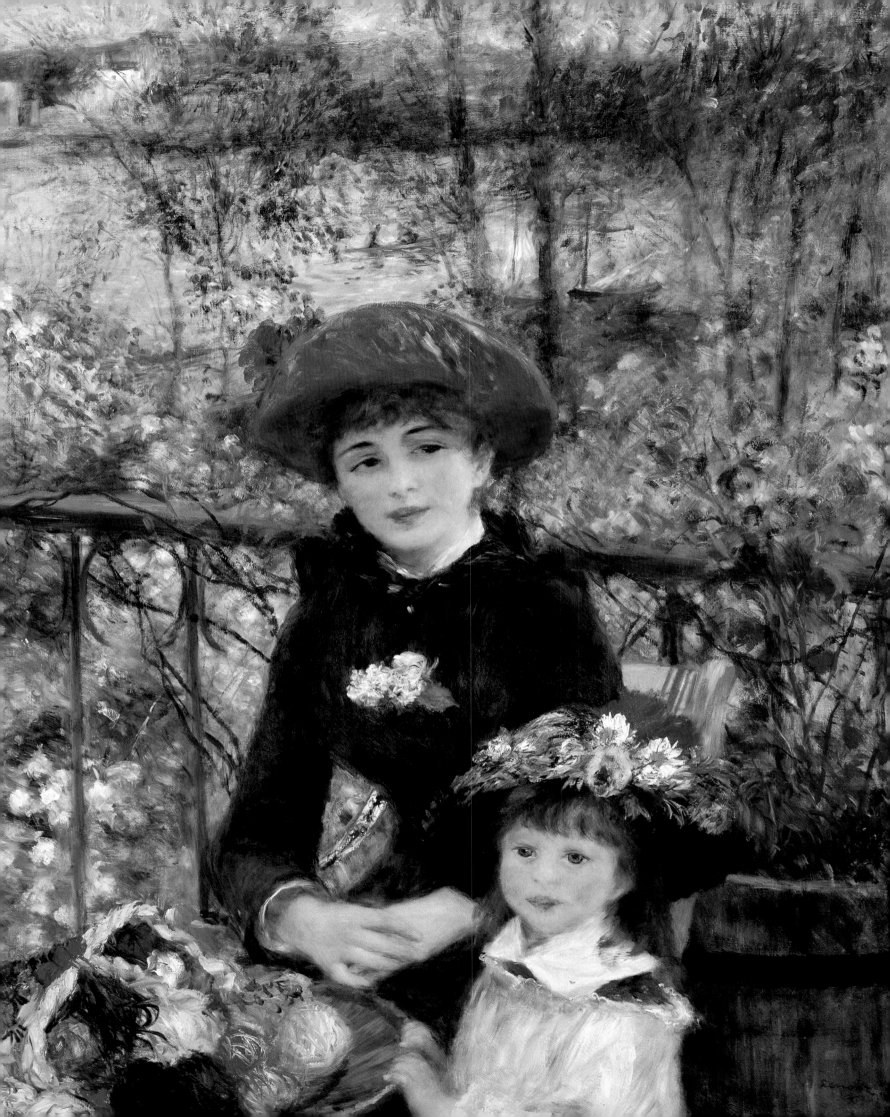

See Plate 22

42

CLAUDE MONET
(1840–1926)

The Parc Monceau
1878

Oil on canvas 73 × 54.5 cm (28³/₄ × 21¹/₂ in)
The Metropolitan Museum of Art, New York

Of all the gardens which formed part of Haussmann's vision of the new Paris, Monet found the Parc Monceau, a picturesque little park landscaped by Adolphe Alphand, the most appealing, for he painted it a number of times in different moods (see also *Paysage: Parc Monceau*, Pl. 30). Originally much larger in area, the park had once belonged to an eighteenth-century château, but part of the land had been sold off to speculators, who built the elegant houses to be glimpsed between the trees in Monet's paintings. It is evident that Monet enjoyed the scene for its social theatre as much as for its delightful natural assets. So too did Emile Zola, who had referred to the park in his novel *La Curée*:
'This charming corner of new Paris, this clean, smiling bit of nature, these lawns like skirts of velvet, figured with flowerbeds and choice shrubs, and bordered with magnificent white roses. Carriages passed one another, as numerous as on the boulevards; the ladies on foot trailed their skirts languorously, as though they had not lifted a foot from the carpets of their drawing-rooms. And they criticized the dresses across the foliage, pointed to the horses, taking a genuine pleasure in the soft colours of this great garden.'
In the gently curving parkland of *Paysage: Parc Monceau* Monet's own palette of 'soft colours' matches the fresh, luminous atmosphere of a mild spring day. His brush is enjoyably liberated and carefree. By contrast, in *The Parc Monceau* the view narrows and darkens dramatically. It is almost as though we were entering a lofty cathedral on a hot day as we join the nursemaids and children and a solitary gentleman in the shade. Here Monet is at his most sensational in exploiting the deepest of shadows to create even more dazzling effects of light. This striking chiaroscuro is achieved entirely without the use of black, which Monet had banished from his palette in 1873. Instead he creates patches of shade from densely worked strokes of deep greens, and then, where the sun pierces the trees, introduces surprisingly animated moments with bright slashes of colour.

(Plate Overleaf)

43

CAMILLE PISSARRO
(1830–1903)

Garden of Les Mathurins, Pontoise
c. 1876

Oil on canvas 112.7 × 165.4 cm (44³/₈ × 65¹/₈ in)
Nelson-Atkins Museum of Art, Kansas City

See Plate 22

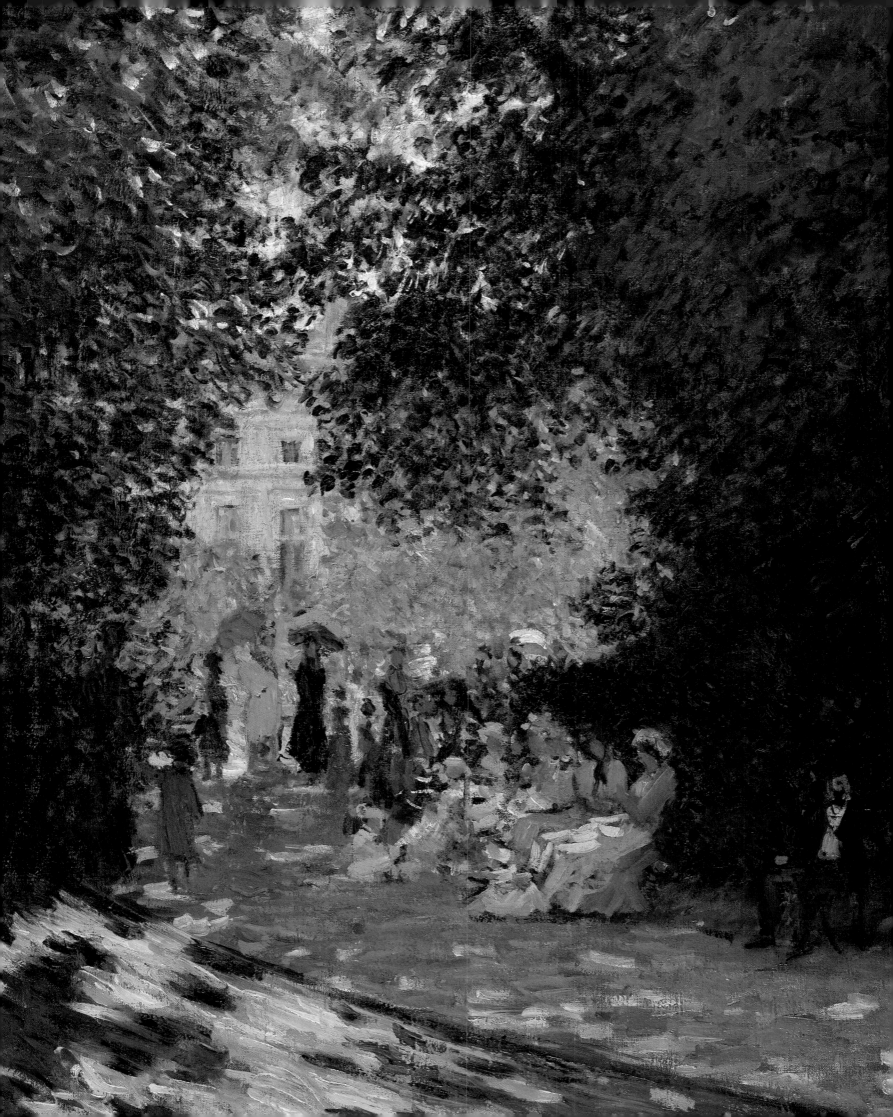

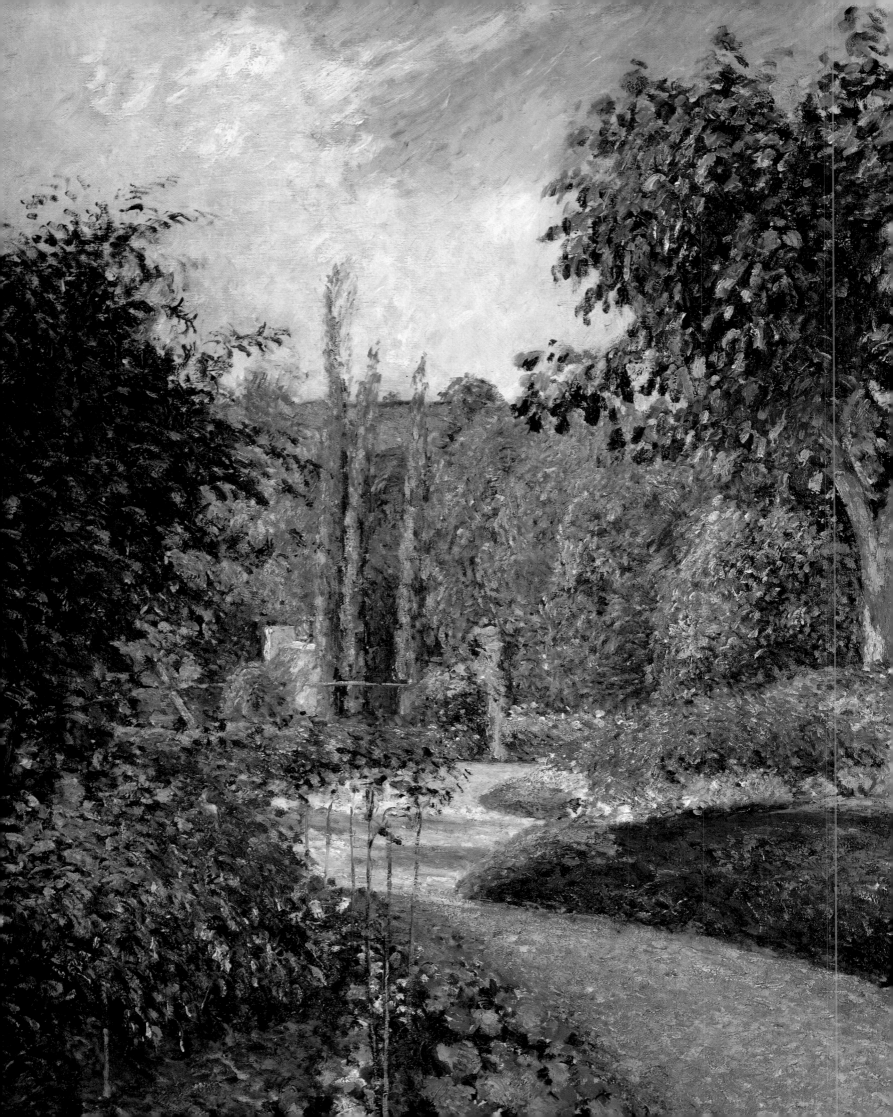

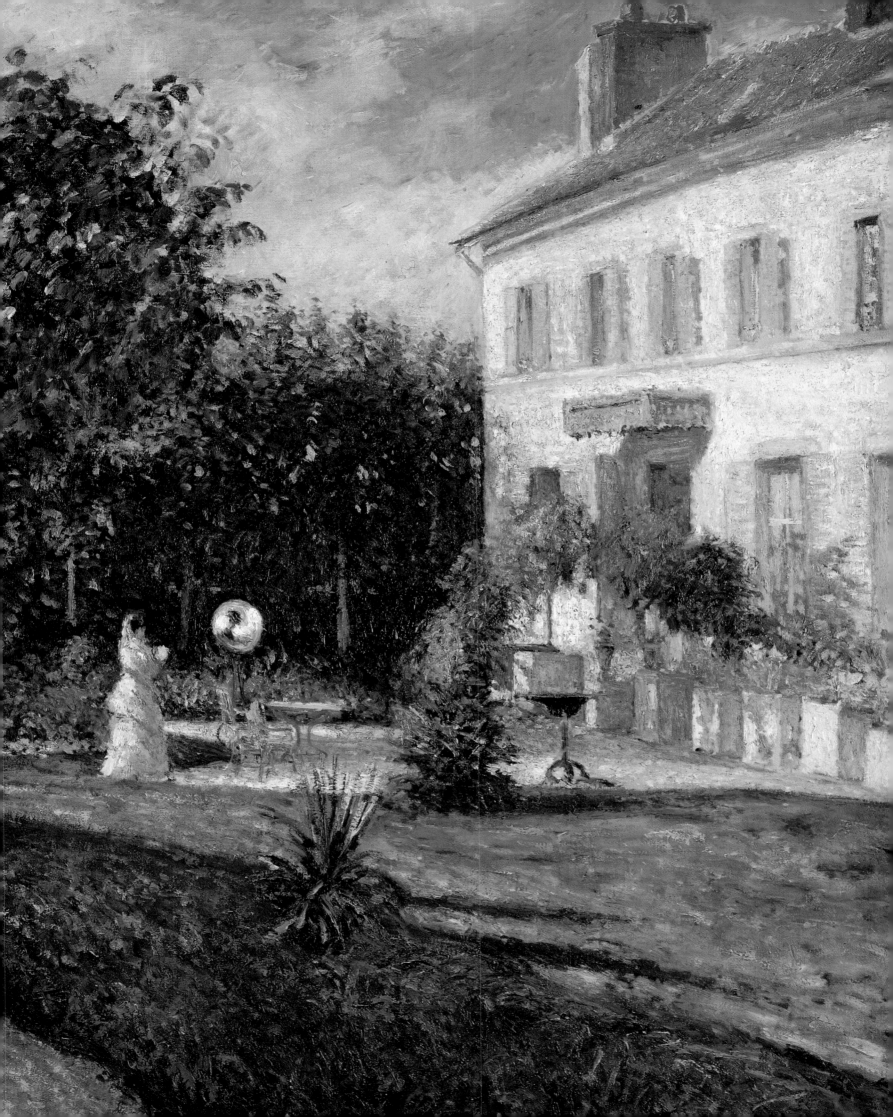

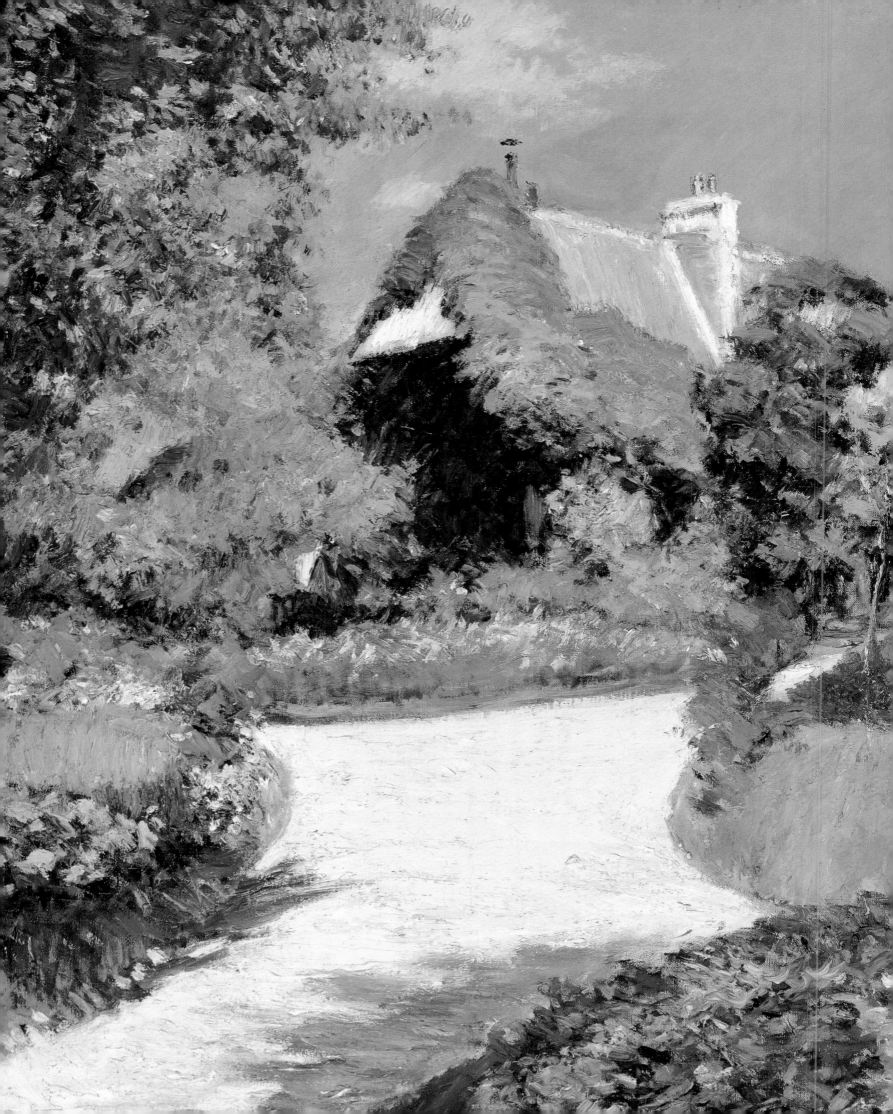

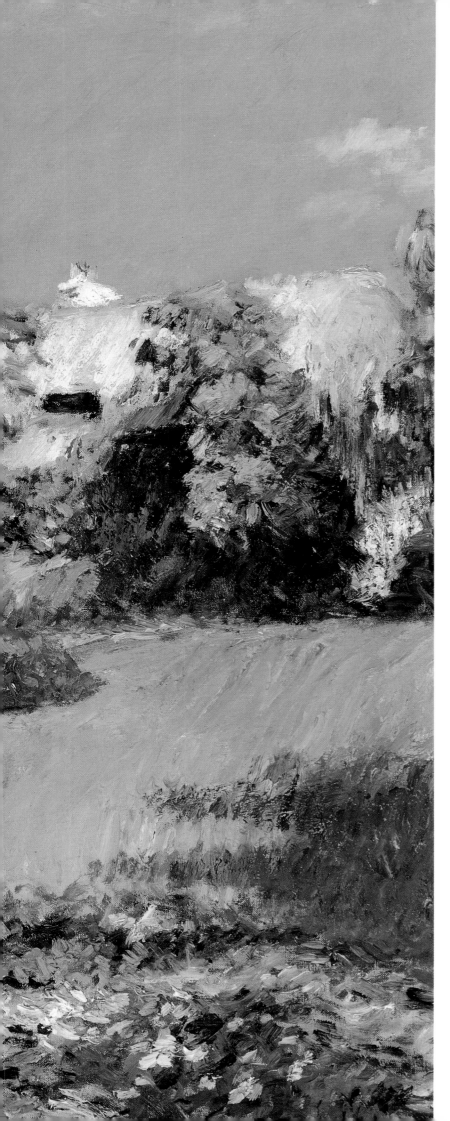

GUSTAVE CAILLEBOTTE
(1848–94)

Thatched Cottage at Trouville
1882

Oil on canvas 54 × 65 cm (21¼ × 25⅝ in)
The Art Institute of Chicago

This ornamental thatched 'cottage' with its spectacular flowering garden was painted inland from the coastal resort of Trouville. Compared to the neat formality of Caillebotte's own rosarium at Petit-Gennevilliers (Pl. 34), this garden, burgeoning with flowers and foliage, emulates the naturalness of the *jardin anglais*. The slender trunk of a birch tree holds the casually dressed appearance together in the centre like a fine pin. It was just the sort of undisturbed scene that fostered the rural fantasies of well-to-do Parisians: sun-baked paths, fresh green lawns, creeper-covered walls and a wealth of colour. The painterly manner with which Caillebotte evokes the pervasive sense of breezy light and colour in a welter of brushy marks, shows him at his most characteristically and vitally Impressionist.

As a notable boating enthusiast, Caillebotte visited this part of the coast annually for the regattas of the Cercle de Paris. He even designed a series of racing yachts. Between 1880 and 1887 he stayed several times in Normandy, painting the elegant sixties villas which had been built in the countryside overlooking the beach for the high society of the Second Empire. The 'Villa des Fleurs' was one that Caillebotte found particular pleasure in recording. Among other garden pictures were many of his family home in Yerres, of the picturesque Parc Monceau in Paris, and of flowery balconies on the apartment blocks of Haussmann's new Paris, as well as of the flowering fields and orchards around Petit-Gennevilliers.

CLAUDE MONET
(1840–1926)

Flowerbeds at Vétheuil
1881

Oil on canvas 92.5 × 73.5 cm (36¹/₂ × 29 in)
Museum of Fine Arts, Boston

In August 1878 Monet moved away from Argenteuil
in search of more peaceful rural surroundings. He
found them in Vétheuil, an unspoilt village further
downstream on the Seine, from where two years later
he would write contentedly to his friend, the critic
Théodore Duret, that he was 'becoming more and
more like a peasant'. In Vétheuil he again took
rented accommodation and his landlady allowed him
to cultivate a plot of land across the road. He
reinstalled his blue and white pots, planted with
flowers, and set about creating a lavish display of
bright colour. One view of the house, picked out in
pastel shades of predominantly pink, blue, green and
yellow, shows a mass of great sunflower heads in the
tall clumps that were already making prolific growth
in the garden (Pl. 9).

At one end the land sloped down to the Seine and
there Monet painted a distant view of the river at
sunset, across a foreground screen of summer
sunflowers and rambling roses. The painting displays
the radiant, richly coloured atmospheric effects that
Monet was pursuing in the early eighties. The forms
of the plants are composed of jewel-like touches.

Dark greens and carmines have been used only
sparingly to model some of the shaded foliage. Even
in a small detail it is possible to appreciate Monet's
masterly orchestration of strong colours, which seem
at first glance to be scattered quite arbitrarily across
the canvas. Clear blue is used with special
effectiveness here to animate forms in shadow and, in
the painting as a whole, to chime with the water and
atmospheric distance.

The abstract calligraphy of Monet's brushwork is
particularly striking in this detail. Monet admired the
economy of the Japanese artist who could 'express life
with the stroke of a pen', and he himself uses an
astoundingly diverse and inventive range of marks to
convey the rampant, tangled growth of vegetation.
The improvised jabs, flecks, painterly curls and trails
of pigment suggest familiar shapes burnished by the
light of the setting sun, without needing to describe
them in detail.

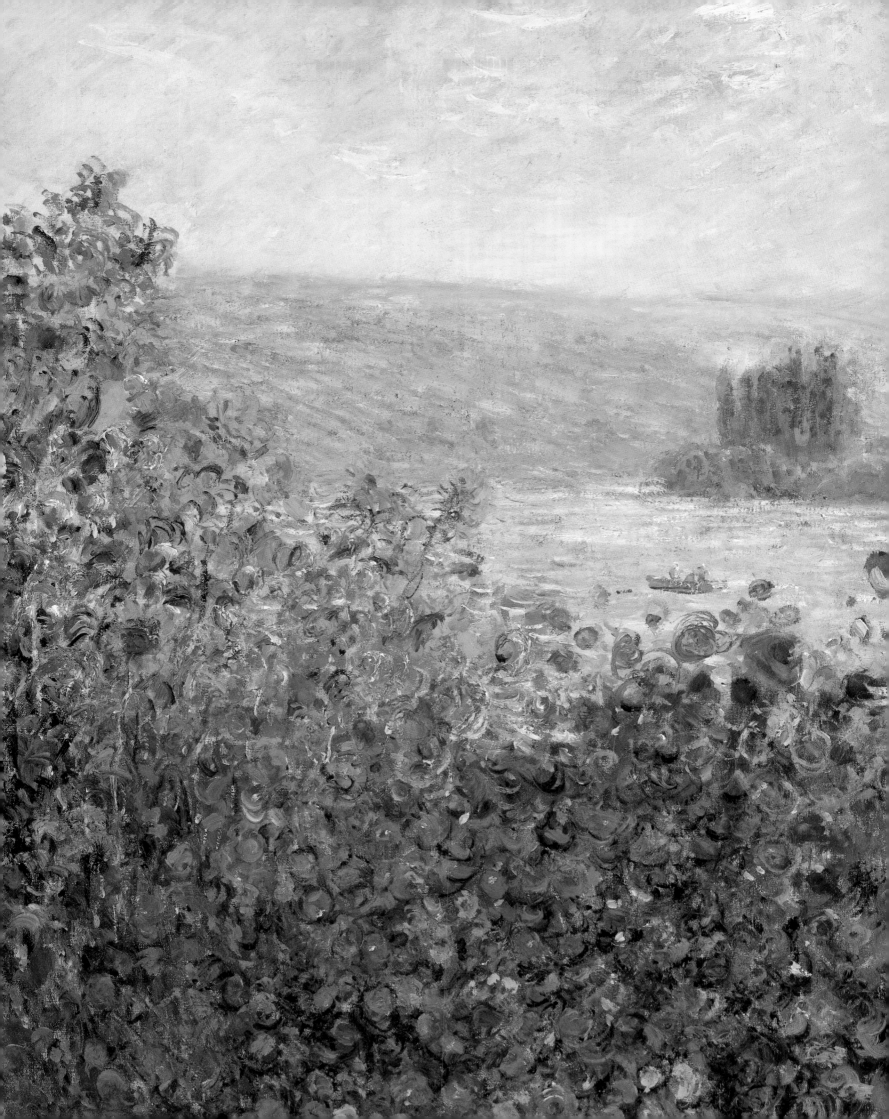

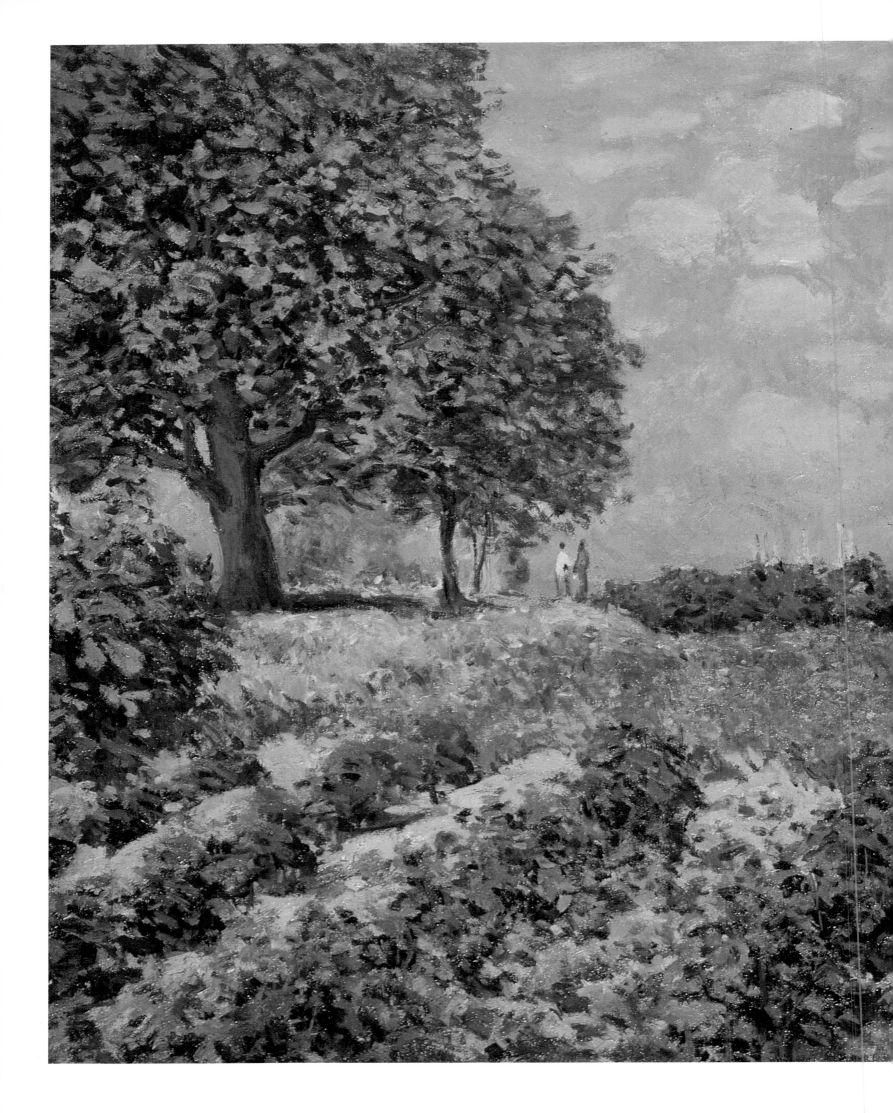

46

ALFRED SISLEY
(1839–99)

The Market Garden
1874

Oil on canvas 116.8 × 155 cm (46 × 61 in)
Leeds City Art Galleries

Rows of vegetables, a sea of green, suggest unpromising material for the artist. Van Gogh made use of it in the patchwork pattern of the Provençal countryside, but Sisley has singled it out as a theme in itself. Focusing on the slope of the garden where the land curved gently to the horizon, Sisley closed the view to the left with a broad leafy tree, leaving a wedge of sky to the right. The compositional elements are, appropriately, of the simplest and with them Sisley composed a poem of the working garden. His own working palette was equally simple, but from it he mixed innumerable and inventive variations on the colour green—blended with blue and yellow, contrasted with red, scattered with white and yellow. In this way he celebrated the fertility and usefulness of nature. Even the colours of the flowers seem to have been absorbed by the decorative nature of the vegetation.

Stylish houses, ornamental gardens and their metropolitan owners are out of sight. So, too, is the railway, which brought increased competition for garden produce from suburban market towns like Louveciennes, the inspiration for Sisley's canvas. The only inhabitants of this garden are unobtrusive. Like the garden stakes, their purpose is practical.

Sisley and Pissarro both went in search of the Barbizon landscape and of untouched rural life and, in communion with it, they discovered beauty in the most unassuming subjects. Unlike Pissarro, who found the summer colours monotonous, Sisley never tired of the lush, clotted greens of the French countryside. Their colours here are so dominant that their vibrations are taken up and echoed in the sky. Sisley may well have reworked this area of blue at a later date and his reversal of the Impressionist treatment of water as a reflective instrument enhances the atmospheric and decorative character of the painting.

47

CLAUDE MONET
(1840–1926)

Water Lilies
1904

Oil on canvas 87.6 × 90.8 cm (34¹/₂ × 35³/₄ in)
Denver Art Museum, Colorado

Even when absent from Giverny Monet's thoughts
continually turned to his garden, as is evident from
instructions sent home to his gardener early in 1900:
'Sowing: around 300 pots Poppies—60 Sweet
pea—around 60 pots white Agremony—30 yellow
Agremony—Blue sage—Blue Water lilies in beds
(greenhouse)—Dahlias—Iris Kaempferi'. The
reference to a greenhouse and to the cultivation of
water lilies shows how seriously Monet took his water
garden by this date. The following year he extended
the site and redesigned the pond, fringing it with
bamboos, irises, agapanthus and petasites, and
replanting it with a variety of lilies.
Theodore Robinson, one of the American painters
who visited Giverny, commented: 'One thing I
remember Monet speaking of, the pleasure he took in
the "pattern" that nature provides — leafage against
sky, reflections, etc.' The pond at Giverny gave rise
to some of the most involved of Monet's visual
patterns. His second series of pond paintings,
executed between 1904 and 1909, focused almost
exclusively on the decorative surface of the water as it
was articulated by the floating plants and
occasionally, as here, bordered by surrounding
greenery. As Monet explained, the real subject of his
exploration was the transistory play of light and
shadow on the water:
'The effect varies constantly, not only from one
season to the next, but from one minute to the next,
since the water flowers are far from being the whole
scene; really, they are just the accompaniment. The
essence of the motif is the mirror of water whose
appearance alters at every moment, thanks to the
patches of the sky that are reflected in it, and which
give it its light and movement.'
These ideas were elaborated in the monumental
Water Landscapes exhibited in 1909 and in the late
almost visionary Water Lily Decorations. In these
paintings the context was completely excluded,
allowing Monet to concentrate solely on the spatial
relationships of the floating clusters and on the
abstract patterns the plant forms wove across the
surface of the canvas.

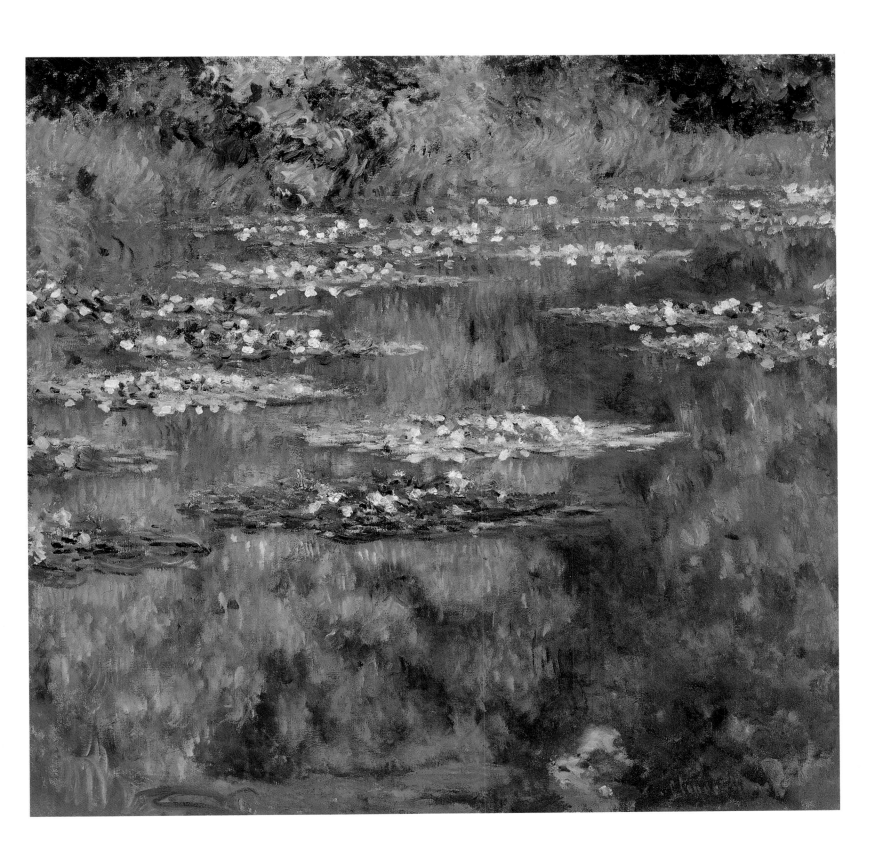

CLAUDE MONET
(1840–1926)

Monet's House at Argenteuil
(detail) 1873

Oil on canvas 60.5 × 74 cm (23³/₄ × 29¹/₈ in)
The Art Institute of Chicago

This was the first of Monet's two homes in Argenteuil. He moved there late in 1871 with Camille and their first son Jean, who was four years old at the time. Its back wall, visible here and in *The Luncheon* (Pl. 24), merely serves as a prop to a much fuller view of the luxuriant garden. Monet was working quite profitably in the early seventies, as his dealer Paul Durand-Ruel was buying work from him, so Monet could afford to indulge his interest in the garden. As we can see here, and in his later gardens in Vétheuil and Giverny, he had a taste for bright, multicoloured displays (see also title page). His notebook for 1872–5, for example, lists a sequence of colours for seven rows of hollyhocks: purple, white, red, violet, yellow, cream and pink. The large blue and white stoneware pots filled with plants add to the decorative character of the garden. Monet is said to have brought them back with him from a trip to Holland in 1871, and he was clearly much attached to them as he took them with him when he moved house to Vétheuil, where they again appear in his paintings of the garden, and to Giverny. Brought inside in the winter, they also feature in some of his interior scenes.

Jean is playing on the path with his hoop, watched from the top of the house steps by a woman, not included in this detail, who is probably his mother Camille. The figures are of incidental narrative interest and do not command attention in this informal study. As in *The Luncheon* their human presence reinforces the idea of the garden as a place of social harmony. We know that Monet became disillusioned with the industrial and commercial developments in the town and has done his best to screen off the surrounding houses. Gradually modern life became of less and less interest to his art and the garden provided him with all that he needed as a sanctum for the human spirit.

FURTHER READING

Arts Council of Great Britain *Renoir*, exhibition catalogue by John House and Anne Distel, London, 1985

Herbert, Robert L. *Impressionism: Art, Leisure, and Parisian Society*, New Haven and London, 1988

House, John *Monet: Nature into Art*, New Haven and London, 1986

Joyes, Claire *Claude Monet: Life at Giverny*, London, 1985

Kendall, Richard (ed.) *Monet by himself*, London, 1989

Kunstler, Charles *Camille Pissarro*, English edn., London, 1988

Los Angeles County Museum of Art *A Day in the Country: Impressionism and the French Landscape*, exhibition catalogue by R. Brettell, S. Schaefer and S. Gache-Patin, 1984

Metropolitan Museum of Art *Monet's Years at Giverny: Beyond Impressionism* exhibition catalogue, New York, 1978

Pissarro, Camille *Letters to his Son Lucien*, edited by John Rewald, with the assistance of Lucien Pissarro, 4th edn., London and Henley, 1980

Renoir, Jean *Renoir, My Father*, English edn., London and Boston, 1962

Rewald, John *The History of Impressionism*, 4th rev. edn., New York and London, 1973

Rey, Jean Dominique *Berthe Morisot*, Naefels, 1982

Rouart, Denis (ed.) *The Correspondence of Berthe Morisot with her Family and her Friends*, English edn. with Introduction and notes by Kathleen Adler and Tamar Garb, London, 1986

Stuckey, Charles F. and William P. Scott *Berthe Morisot, Impressionist*, New York and London, 1987

Tucker, Paul Hayes *Monet at Argenteuil*, New Haven and London, 1982

Varnedoe, Kirk *Gustave Caillebotte*, New Haven and London, 1987

Zola, Emile *La Curée* 1871

PHOTOGRAPHIC ACKNOWLEDGEMENTS

45 Museum of Fine Arts, Boston, gift of Theodora Lyman. © The Art Institute of Chicago, All Rights Reserved: 37, 39, 41 Mr and Mrs Lewis Larned Coburn Memorial Collection; 40, 48 Mr and Mrs Martin A. Ryerson Collection; 44 Gift of Frank H. and Louise B. Woods. 31 Cincinnati Art Museum, gift of Mark P. Herschede. 2 Detroit Institute of Arts, city of Detroit purchase. 3 Wadsworth Atheneum, Hartford, bequest of Anne Parrish Titzell. 28 The Museum of Fine Arts, Houston, The Robert Lee Blaffer Memorial Collection, gift of Sarah Campbell Blaffer. 43 The Nelson-Atkins Museum of Art, Kansas City, Missouri (Nelson Fund). 10 L'Illustration/Sygma from the John Hillelson Agency Ltd. 38 the Minneapolis Institute of Arts, bequest of Putnam Dana McMillan. © The Metropolitan Museum of Art, New York: 27 Purchased with special contributions and purchase funds given or bequeathed by friends of the Museum; 29 Bequest of Joan Whitney Payson; 30 Bequest of Loula D. Lasker, New York City; 42 Mr and Mrs Henry Ittleson, Jr., Fund. 4 Studio Lourmel, Paris. 21, 22, 24, 32, 35, 36 © Photo R.M.N. 17 All Rights Reserved, Document Archives Durand-Ruel. 26 Carnegie Museum of Art, Pittsburgh, acquired through the generosity of Mrs Alan M. Scaife. 9 National Gallery of Art, Washington DC, Ailsa Mellon Bruce Collection.

49

HENRI ROUART (1833–1912)
Young Woman Reading c. 1880
Oil on canvas 45 × 60 cm (17³/₄ × 23¹/₄ in) Private Collection

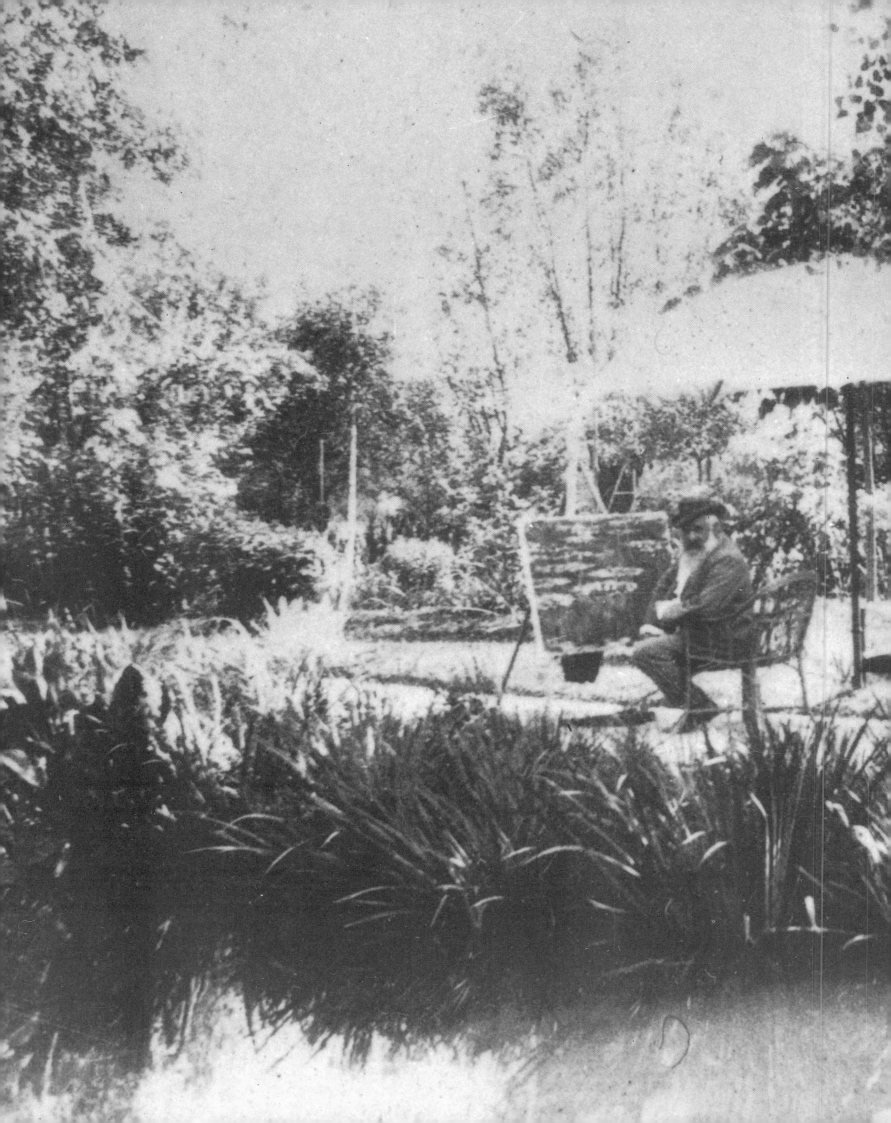